2 0 0 2 E N G A G E M E N T C A L E N D A R

GW00697380

A N S E L A D A M S

LITTLE, BROWN AND COMPANY BOSTON · NEW YORK · LONDON

● New Moon
◐ First Quarter
○ Full Moon
◑ Last Quarter

FRONT COVER: Moon and Mount McKinley, Denali National Park, Alaska, 1947
BACK COVER: Ansel Adams working in his darkroom, San Francisco, c. 1930 (by Virginia Adams)

ISBN 0-8212-2584-7

Designed by Pentagram/Jean Wilcox
Printed by Gardner Lithograph

Printed in the United States of America

ANSEL ADAMS

To photograph truthfully and effectively is to see beneath the surfaces and record the qualities of nature and humanity which live or are latent in all things. Impression is not enough. Design, style, technique—these, too, are not enough. Art must reach further than impression or self-revelation. Art, said Alfred Stieglitz, is the affirmation of life. And life, or its eternal evidence, is everywhere.

Some photographers take reality as the sculptors take wood and stone and impose upon it the dominations of their own thought and spirit. Others come before reality more tenderly and a photograph to them is an instrument of love and revelation. A true photograph need not be explained, nor can be contained in words.

—from *The Portfolios of Ansel Adams*, Portfolio One, 1948

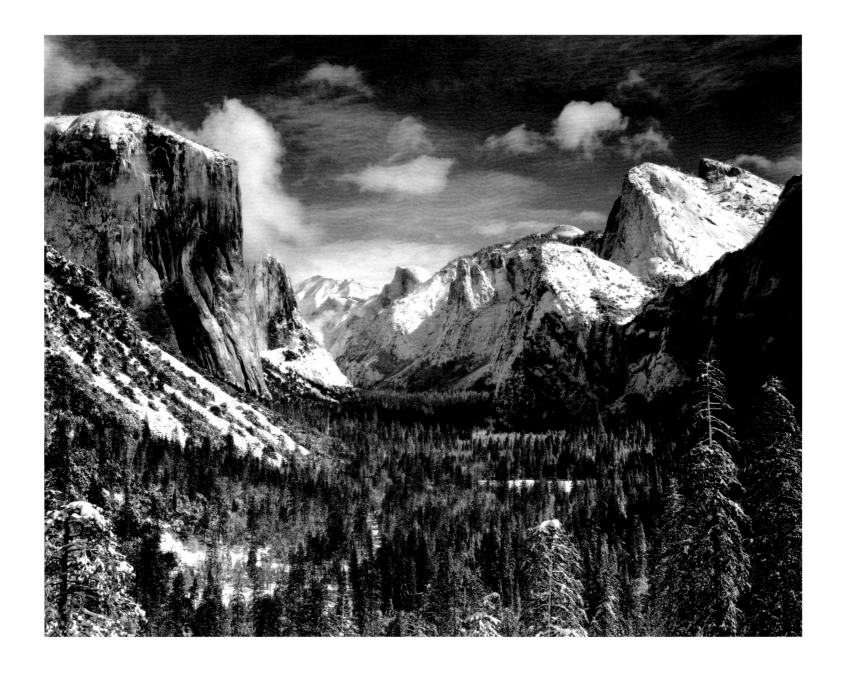

Yosemite Valley, Winter, from Inspiration Point, Yosemite National Park, California, c. 1940

DECEMBER/JANUARY

31 MONDAY

a.m.

p.m.

1 TUESDAY

a.m.

p.m.

New Year's Day

2 WEDNESDAY

a.m.

p.m.

3 THURSDAY

a.m.

p.m.

4 FRIDAY

a.m.

p.m.

5 SATURDAY

6 SUNDAY

DECEMBER

S	M	T	W	T	F	S
						1
2	3	4	5	6	7	8
9	10	11	12	13	14	15
16	17	18	19	20	21	22
23	24	25	26	27	28	29
30	31					

NOVEMBER

S	M	T	W	T	F	S
				1	2	3
4	5	6	7	8	9	10
11	12	13	14	15	16	17
18	19	20	21	22	23	24
25	26	27	28	29	30	

JANUARY

S	M	T	W	T	F	S
		1	2	3	4	5
6	7	8	9	10	11	12
13	14	15	16	17	18	19
20	21	22	23	24	25	26
27	28	29	30	31		

JANUARY

7 MONDAY

a.m.

p.m.

8 TUESDAY

a.m.

p.m.

9 WEDNESDAY

a.m.

p.m.

10 THURSDAY

a.m.

p.m.

11 FRIDAY

a.m.

p.m.

12 SATURDAY

13 SUNDAY ●

JANUARY

S	M	T	W	T	F	S
		1	2	3	4	5
6	7	8	9	10	11	12
13	14	15	16	17	18	19
20	21	22	23	24	25	26
27	28	29	30	31		

DECEMBER

S	M	T	W	T	F	S
						1
2	3	4	5	6	7	8
9	10	11	12	13	14	15
16	17	18	19	20	21	22
23	24	25	26	27	28	29
30	31					

FEBRUARY

S	M	T	W	T	F	S
					1	2
3	4	5	6	7	8	9
10	11	12	13	14	15	16
17	18	19	20	21	22	23
24	25	26	27	28		

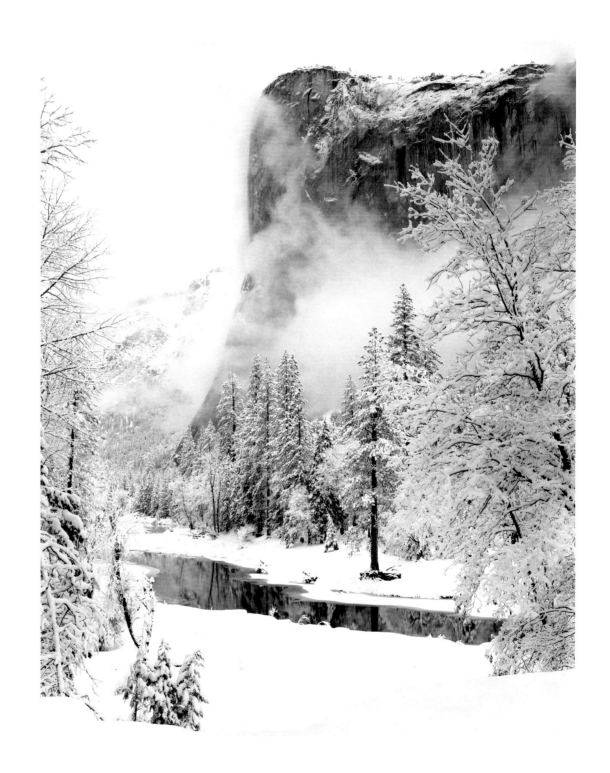

El Capitan, Winter,
Yosemite National Park,
California, 1948

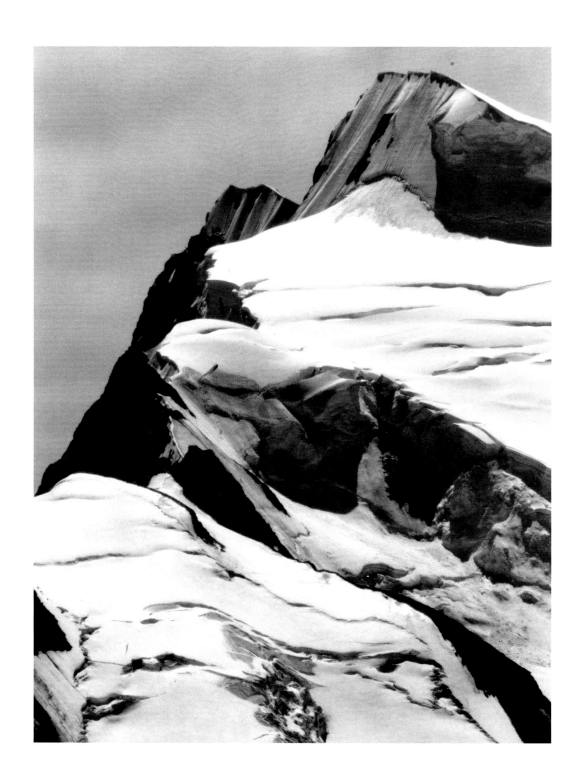

Mount Resplendent, Mount Robson
National Park, Canada, 1928

JANUARY

14 MONDAY

a.m.

p.m.

15 TUESDAY

a.m.

p.m.

16 WEDNESDAY

a.m.

p.m.

17 THURSDAY

a.m.

p.m.

18 FRIDAY

a.m.

p.m.

19 SATURDAY

20 SUNDAY

JANUARY

S	M	T	W	T	F	S
		1	2	3	4	5
6	7	8	9	10	11	12
13	14	15	16	17	18	19
20	21	22	23	24	25	26
27	28	29	30	31		

DECEMBER

S	M	T	W	T	F	S
						1
2	3	4	5	6	7	8
9	10	11	12	13	14	15
16	17	18	19	20	21	22
23	24	25	26	27	28	29
30	31					

FEBRUARY

S	M	T	W	T	F	S
					1	2
3	4	5	6	7	8	9
10	11	12	13	14	15	16
17	18	19	20	21	22	23
24	25	26	27	28		

JANUARY

21 MONDAY ◑

a.m.

p.m.

Martin Luther King Jr. Day

22 TUESDAY

a.m.

p.m.

23 WEDNESDAY

a.m.

p.m.

24 THURSDAY

a.m.

p.m.

25 FRIDAY

a.m.

p.m.

26 SATURDAY

27 SUNDAY

JANUARY

S	M	T	W	T	F	S	
			1	2	3	4	5
6	7	8	9	10	11	12	
13	14	15	16	17	18	19	
20	21	22	23	24	25	26	
27	28	29	30	31			

DECEMBER

S	M	T	W	T	F	S
						1
2	3	4	5	6	7	8
9	10	11	12	13	14	15
16	17	18	19	20	21	22
23	24	25	26	27	28	29
30	31					

FEBRUARY

S	M	T	W	T	F	S
					1	2
3	4	5	6	7	8	9
10	11	12	13	14	15	16
17	18	19	20	21	22	23
24	25	26	27	28		

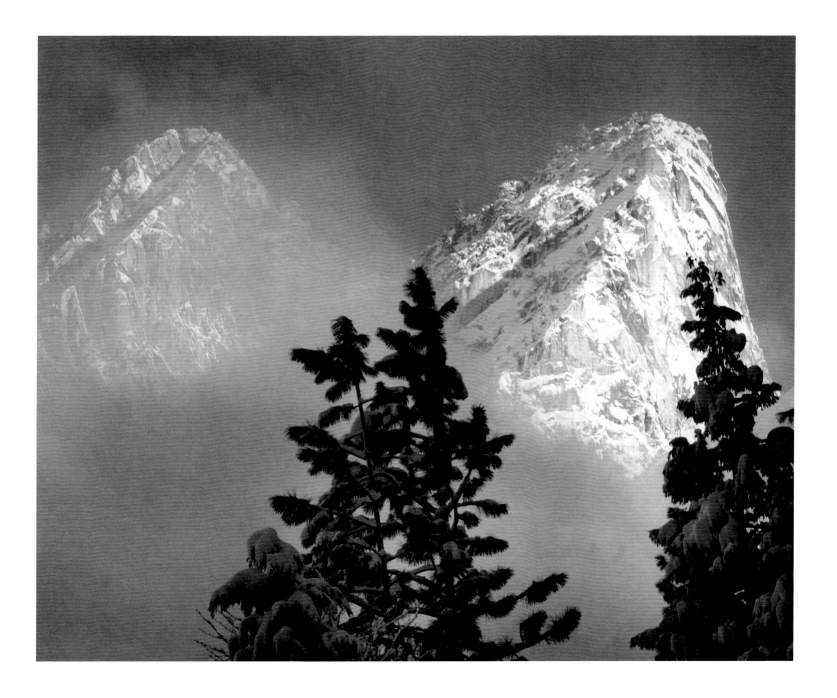

Eagle Peak and Middle Brother, Yosemite National Park, California, c. 1968

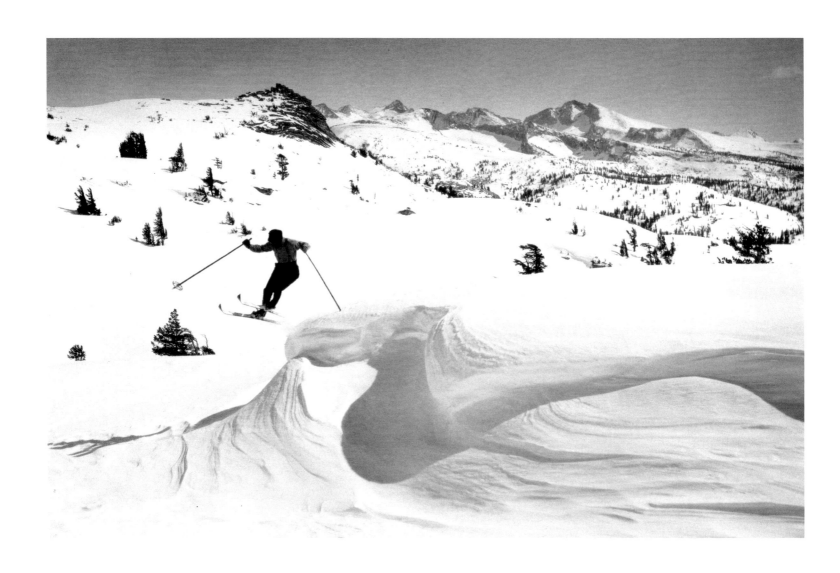

Skier, Yosemite National Park, California, 1930

JANUARY/FEBRUARY

28 MONDAY ○

a.m.

p.m.

29 TUESDAY

a.m.

p.m.

30 WEDNESDAY

a.m.

p.m.

31 THURSDAY

a.m.

p.m.

1 FRIDAY

a.m.

p.m.

2 SATURDAY

3 SUNDAY

JANUARY

S	M	T	W	T	F	S	
			1	2	3	4	5
6	7	8	9	10	11	12	
13	14	15	16	17	18	19	
20	21	22	23	24	25	26	
27	28	29	30	31			

DECEMBER

S	M	T	W	T	F	S
						1
2	3	4	5	6	7	8
9	10	11	12	13	14	15
16	17	18	19	20	21	22
23	24	25	26	27	28	29
30	31					

FEBRUARY

S	M	T	W	T	F	S
					1	2
3	4	5	6	7	8	9
10	11	12	13	14	15	16
17	18	19	20	21	22	23
24	25	26	27	28		

FEBRUARY

4 MONDAY ◑	**5** TUESDAY	**6** WEDNESDAY
a.m.	a.m.	a.m.
p.m.	p.m.	p.m.

7 THURSDAY	**8** FRIDAY	**9** SATURDAY
a.m.	a.m.	
p.m.	p.m.	**10** SUNDAY

FEBRUARY

S	M	T	W	T	F	S
					1	2
3	4	5	6	7	8	9
10	11	12	13	14	15	16
17	18	19	20	21	22	23
24	25	26	27	28		

JANUARY

S	M	T	W	T	F	S
		1	2	3	4	5
6	7	8	9	10	11	12
13	14	15	16	17	18	19
20	21	22	23	24	25	26
27	28	29	30	31		

MARCH

S	M	T	W	T	F	S
					1	2
3	4	5	6	7	8	9
10	11	12	13	14	15	16
17	18	19	20	21	22	23
24	25	26	27	28	29	30
31						

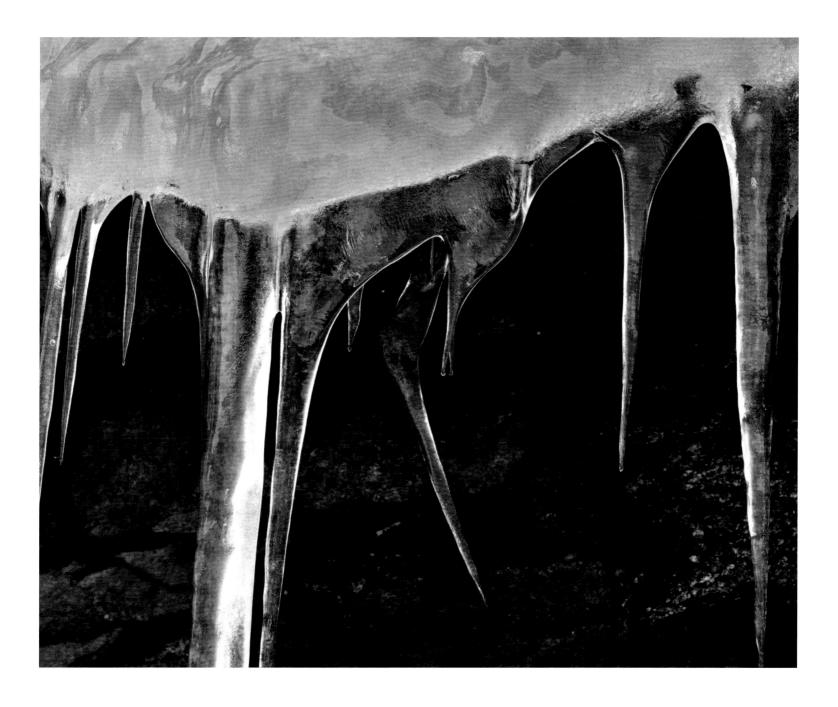

Icicles, Yosemite National Park, California, 1950

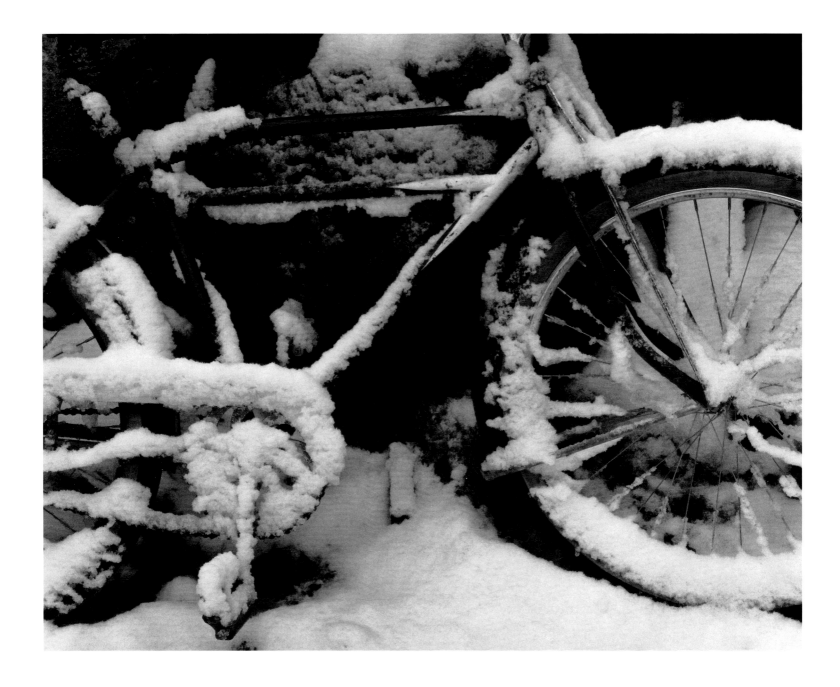

Bicycle, Yosemite National Park, California, 1937

FEBRUARY

11 MONDAY

a.m.

p.m.

12 TUESDAY

a.m.

p.m.

Lincoln's Birthday

Chinese New Year

13 WEDNESDAY

a.m.

p.m.

Ash Wednesday

14 THURSDAY

a.m.

p.m.

Valentine's Day

15 FRIDAY

a.m.

p.m.

16 SATURDAY

17 SUNDAY

FEBRUARY

S	M	T	W	T	F	S
					1	2
3	4	5	6	7	8	9
10	11	12	13	14	15	16
17	18	19	20	21	22	23
24	25	26	27	28		

JANUARY

S	M	T	W	T	F	S
		1	2	3	4	5
6	7	8	9	10	11	12
13	14	15	16	17	18	19
20	21	22	23	24	25	26
27	28	29	30	31		

MARCH

S	M	T	W	T	F	S
					1	2
3	4	5	6	7	8	9
10	11	12	13	14	15	16
17	18	19	20	21	22	23
24	25	26	27	28	29	30
31						

FEBRUARY

18 MONDAY

a.m.

p.m.

Presidents' Day

19 TUESDAY

a.m.

p.m.

20 WEDNESDAY ◗

a.m.

p.m.

21 THURSDAY

a.m.

p.m.

22 FRIDAY

a.m.

p.m.

Washington's Birthday

23 SATURDAY

24 SUNDAY

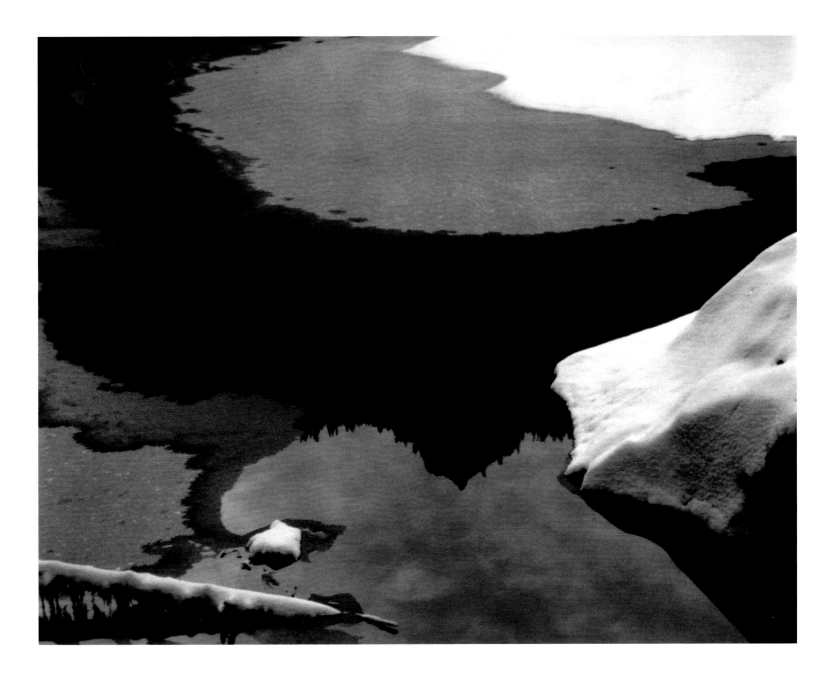

Merced River, Ice, Reflections, Yosemite National Park, California, 1960

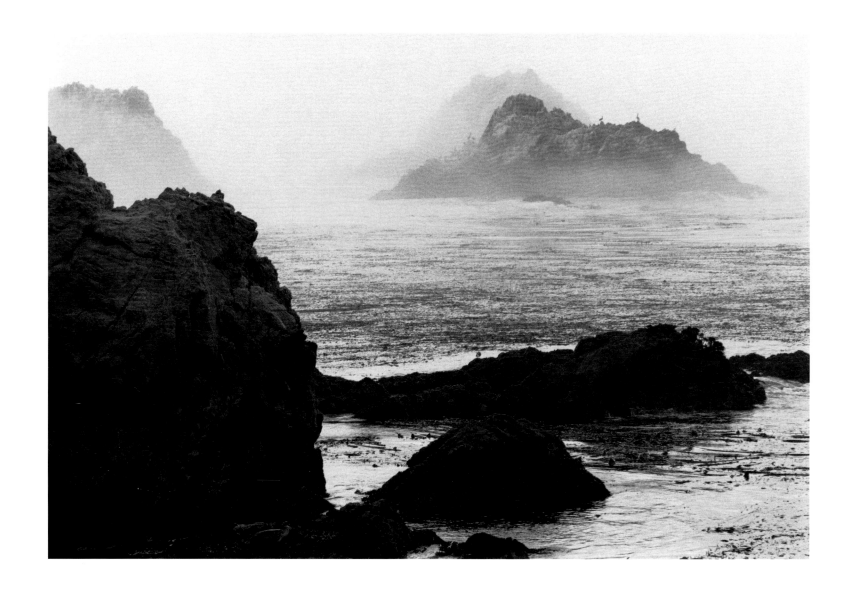

Shoreline in Fog, Point Lobos State Reserve, California, 1981

FEBRUARY/MARCH

25 MONDAY

a.m.

p.m.

26 TUESDAY

a.m.

p.m.

27 WEDNESDAY ○

a.m.

p.m.

28 THURSDAY

a.m.

p.m.

1 FRIDAY

a.m.

p.m.

2 SATURDAY

3 SUNDAY

FEBRUARY

S	M	T	W	T	F	S
					1	2
3	4	5	6	7	8	9
10	11	12	13	14	15	16
17	18	19	20	21	22	23
24	25	26	27	28		

JANUARY

S	M	T	W	T	F	S
		1	2	3	4	5
6	7	8	9	10	11	12
13	14	15	16	17	18	19
20	21	22	23	24	25	26
27	28	29	30	31		

MARCH

S	M	T	W	T	F	S
					1	2
3	4	5	6	7	8	9
10	11	12	13	14	15	16
17	18	19	20	21	22	23
24	25	26	27	28	29	30
31						

MARCH

4 MONDAY

a.m.

p.m.

5 TUESDAY ◑

a.m.

p.m.

6 WEDNESDAY

a.m.

p.m.

7 THURSDAY

a.m.

p.m.

8 FRIDAY

a.m.

p.m.

9 SATURDAY

10 SUNDAY

MARCH

S	M	T	W	T	F	S
					1	2
3	4	5	6	7	8	9
10	11	12	13	14	15	16
17	18	19	20	21	22	23
24	25	26	27	28	29	30
31						

FEBRUARY

S	M	T	W	T	F	S
					1	2
3	4	5	6	7	8	9
10	11	12	13	14	15	16
17	18	19	20	21	22	23
24	25	26	27	28		

APRIL

S	M	T	W	T	F	S
	1	2	3	4	5	6
7	8	9	10	11	12	13
14	15	16	17	18	19	20
21	22	23	24	25	26	27
28	29	30				

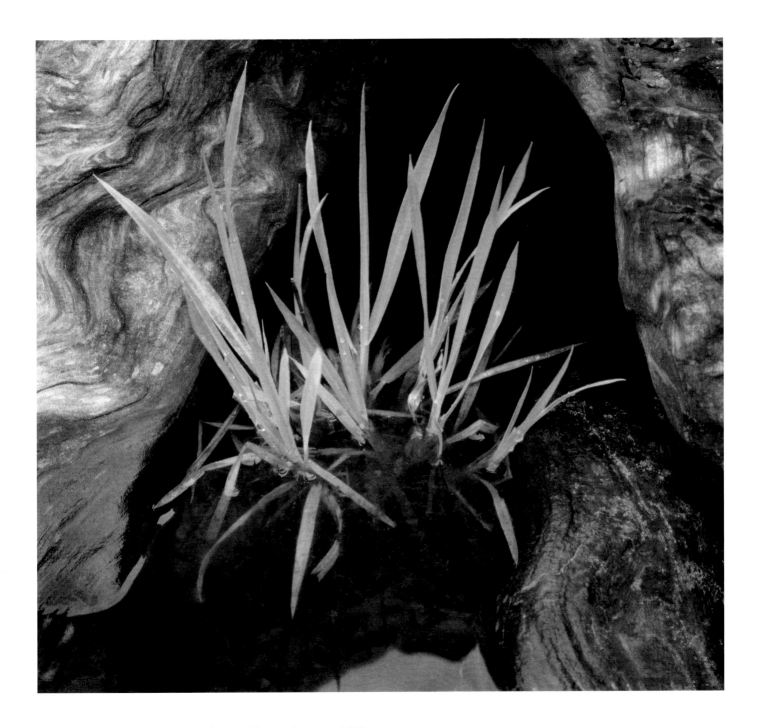

New Grass, Water and Rocks, Northern California Coast, c. 1970

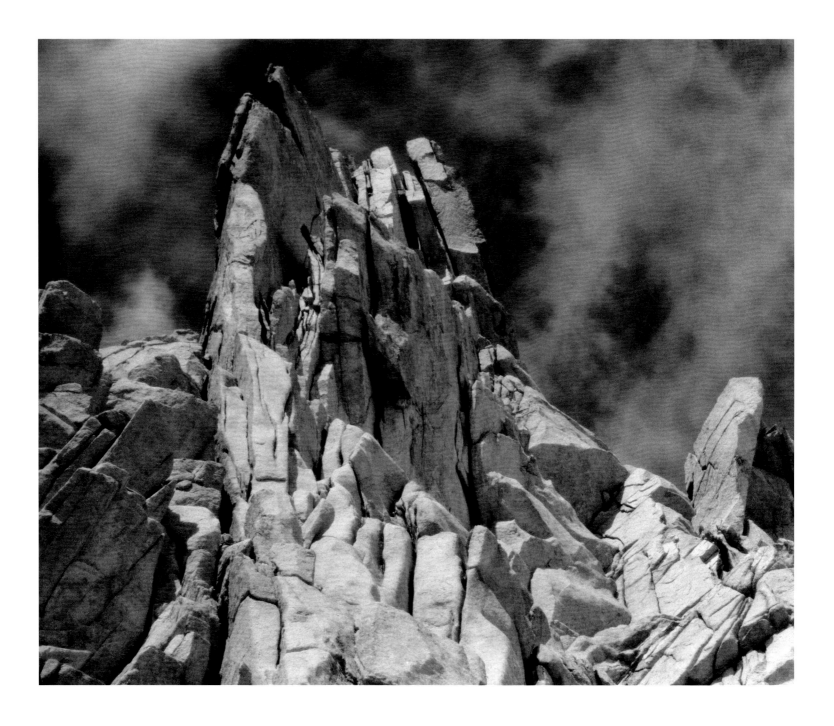

Granite Crags, Sierra Nevada, California, 1927

MARCH

11 MONDAY

a.m.

p.m.

12 TUESDAY

a.m.

p.m.

13 WEDNESDAY ●

a.m.

p.m.

14 THURSDAY

a.m.

p.m.

15 FRIDAY

a.m.

p.m.

16 SATURDAY

17 SUNDAY

St. Patrick's Day

MARCH

S	M	T	W	T	F	S
					1	2
3	4	5	6	7	8	9
10	11	12	13	14	15	16
17	18	19	20	21	22	23
24	25	26	27	28	29	30
31						

FEBRUARY

S	M	T	W	T	F	S
					1	2
3	4	5	6	7	8	9
10	11	12	13	14	15	16
17	18	19	20	21	22	23
24	25	26	27	28		

APRIL

S	M	T	W	T	F	S
	1	2	3	4	5	6
7	8	9	10	11	12	13
14	15	16	17	18	19	20
21	22	23	24	25	26	27
28	29	30				

MARCH

18 MONDAY

a.m.

p.m.

19 TUESDAY

a.m.

p.m.

20 WEDNESDAY

a.m.

p.m.

Vernal Equinox

21 THURSDAY ◗

a.m.

p.m.

22 FRIDAY

a.m.

p.m.

23 SATURDAY

24 SUNDAY

Palm Sunday

MARCH

S	M	T	W	T	F	S
					1	2
3	4	5	6	7	8	9
10	11	12	13	14	15	16
17	18	19	20	21	22	23
24	25	26	27	28	29	30
31						

FEBRUARY

S	M	T	W	T	F	S
					1	2
3	4	5	6	7	8	9
10	11	12	13	14	15	16
17	18	19	20	21	22	23
24	25	26	27	28		

APRIL

S	M	T	W	T	F	S
	1	2	3	4	5	6
7	8	9	10	11	12	13
14	15	16	17	18	19	20
21	22	23	24	25	26	27
28	29	30				

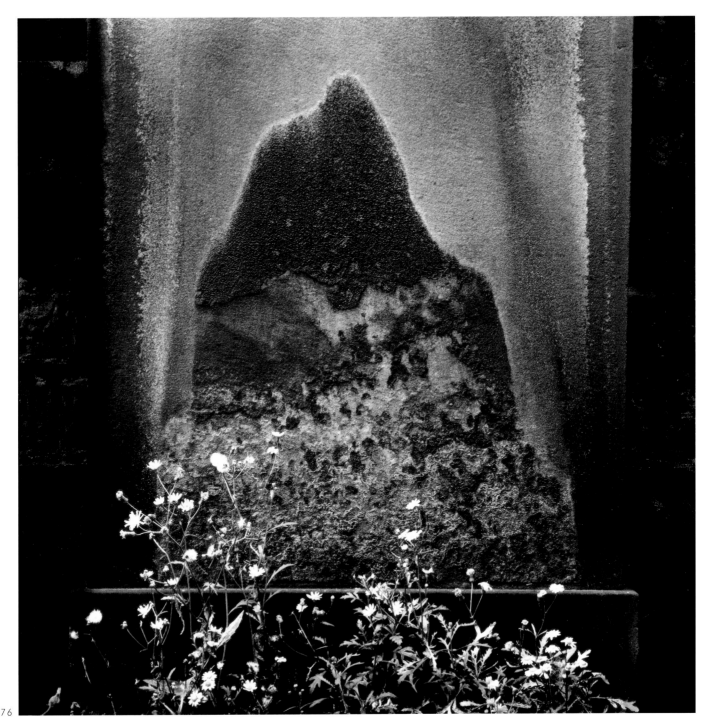

Cemetery,
Edinburgh,
Scotland, 1976

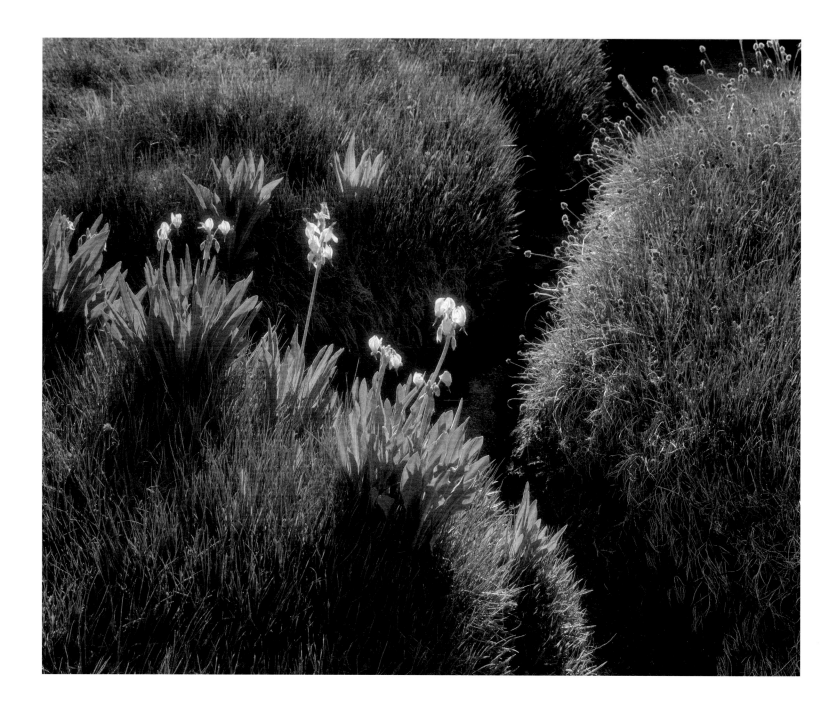

Meadow Detail, Sequoia National Park, California, 1930

MARCH

25 MONDAY

a.m.

p.m.

26 TUESDAY

a.m.

p.m.

27 WEDNESDAY

a.m.

p.m.

28 THURSDAY ○

a.m.

p.m.

Passover

29 FRIDAY

a.m.

p.m.

Good Friday

30 SATURDAY

31 SUNDAY

Easter Sunday

APRIL

1 MONDAY

a.m.

p.m.

Easter Monday (Canada)

2 TUESDAY

a.m.

p.m.

3 WEDNESDAY

a.m.

p.m.

4 THURSDAY ◑

a.m.

p.m.

5 FRIDAY

a.m.

p.m.

6 SATURDAY

7 SUNDAY

Daylight Saving Time begins

APRIL

S	M	T	W	T	F	S
	1	2	3	4	5	6
7	8	9	10	11	12	13
14	15	16	17	18	19	20
21	22	23	24	25	26	27
28	29	30				

MARCH

S	M	T	W	T	F	S
					1	2
3	4	5	6	7	8	9
10	11	12	13	14	15	16
17	18	19	20	21	22	23
24	25	26	27	28	29	30
31						

MAY

S	M	T	W	T	F	S
			1	2	3	4
5	6	7	8	9	10	11
12	13	14	15	16	17	18
19	20	21	22	23	24	25
26	27	28	29	30	31	

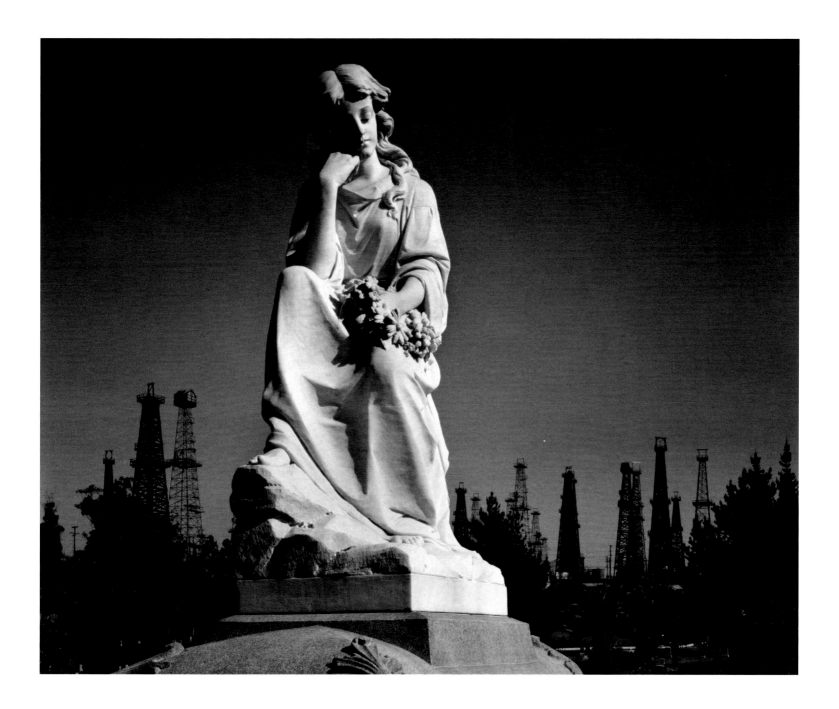

Statue and Oil Derricks, Signal Hill, Long Beach, California, 1939

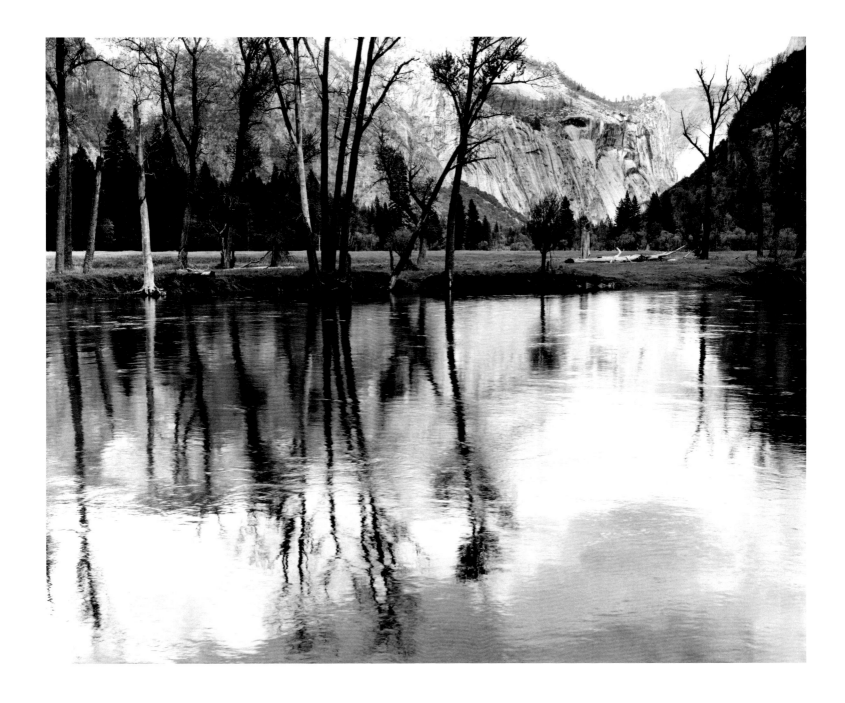

Reflections, Merced River, Yosemite National Park, California, 1948

APRIL

8 MONDAY

a.m.

p.m.

9 TUESDAY

a.m.

p.m.

10 WEDNESDAY

a.m.

p.m.

11 THURSDAY

a.m.

p.m.

12 FRIDAY ●

a.m.

p.m.

13 SATURDAY

14 SUNDAY

APRIL

S	M	T	W	T	F	S	
		1	2	3	4	5	6
7	8	9	10	11	12	13	
14	15	16	17	18	19	20	
21	22	23	24	25	26	27	
28	29	30					

MARCH

S	M	T	W	T	F	S
					1	2
3	4	5	6	7	8	9
10	11	12	13	14	15	16
17	18	19	20	21	22	23
24	25	26	27	28	29	30
31						

MAY

S	M	T	W	T	F	S
			1	2	3	4
5	6	7	8	9	10	11
12	13	14	15	16	17	18
19	20	21	22	23	24	25
26	27	28	29	30	31	

APRIL

15 MONDAY

a.m.

p.m.

16 TUESDAY

a.m.

p.m.

17 WEDNESDAY

a.m.

p.m.

18 THURSDAY

a.m.

p.m.

19 FRIDAY

a.m.

p.m.

20 SATURDAY

21 SUNDAY

APRIL

S	M	T	W	T	F	S	
		1	2	3	4	5	6
7	8	9	10	11	12	13	
14	15	16	17	18	19	20	
21	22	23	24	25	26	27	
28	29	30					

MARCH

S	M	T	W	T	F	S
					1	2
3	4	5	6	7	8	9
10	11	12	13	14	15	16
17	18	19	20	21	22	23
24	25	26	27	28	29	30
31						

MAY

S	M	T	W	T	F	S
			1	2	3	4
5	6	7	8	9	10	11
12	13	14	15	16	17	18
19	20	21	22	23	24	25
26	27	28	29	30	31	

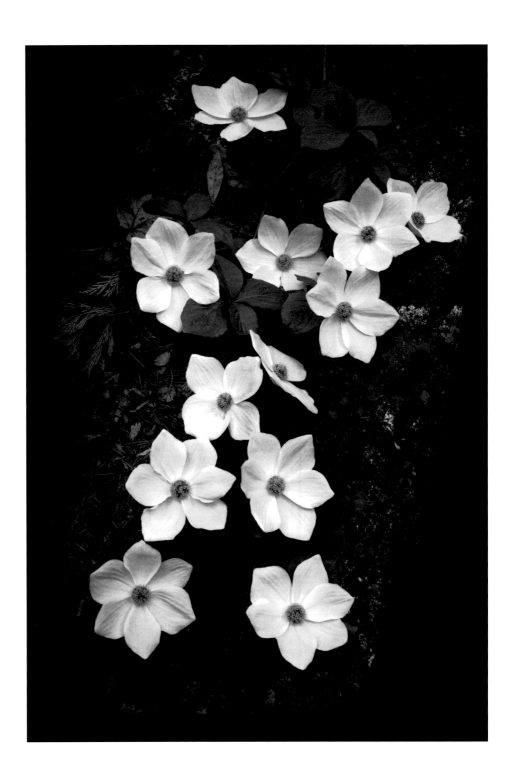

Dogwood, Yosemite National Park,
California, 1938

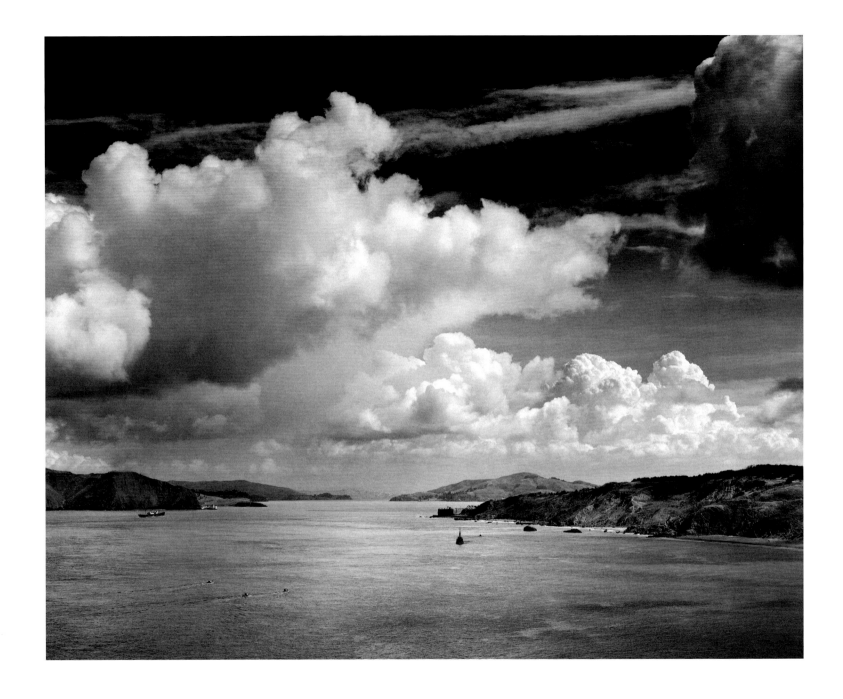

The Golden Gate before the Bridge, San Francisco, California, 1932

APRIL

22 MONDAY

a.m.

p.m.

23 TUESDAY

a.m.

p.m.

24 WEDNESDAY

a.m.

p.m.

25 THURSDAY

a.m.

p.m.

26 FRIDAY ○

a.m.

p.m.

27 SATURDAY

28 SUNDAY

APRIL

S	M	T	W	T	F	S	
		1	2	3	4	5	6
7	8	9	10	11	12	13	
14	15	16	17	18	19	20	
21	22	23	24	25	26	27	
28	29	30					

MARCH

S	M	T	W	T	F	S
					1	2
3	4	5	6	7	8	9
10	11	12	13	14	15	16
17	18	19	20	21	22	23
24	25	26	27	28	29	30
31						

MAY

S	M	T	W	T	F	S
			1	2	3	4
5	6	7	8	9	10	11
12	13	14	15	16	17	18
19	20	21	22	23	24	25
26	27	28	29	30	31	

APRIL / MAY

29 MONDAY

a.m.

p.m.

30 TUESDAY

a.m.

p.m.

1 WEDNESDAY

a.m.

p.m.

2 THURSDAY

a.m.

p.m.

3 FRIDAY

a.m.

p.m.

4 SATURDAY ◑

5 SUNDAY

APRIL

S	M	T	W	T	F	S	
		1	2	3	4	5	6
7	8	9	10	11	12	13	
14	15	16	17	18	19	20	
21	22	23	24	25	26	27	
28	29	30					

MARCH

S	M	T	W	T	F	S
					1	2
3	4	5	6	7	8	9
10	11	12	13	14	15	16
17	18	19	20	21	22	23
24	25	26	27	28	29	30
31						

MAY

S	M	T	W	T	F	S	
				1	2	3	4
5	6	7	8	9	10	11	
12	13	14	15	16	17	18	
19	20	21	22	23	24	25	
26	27	28	29	30	31		

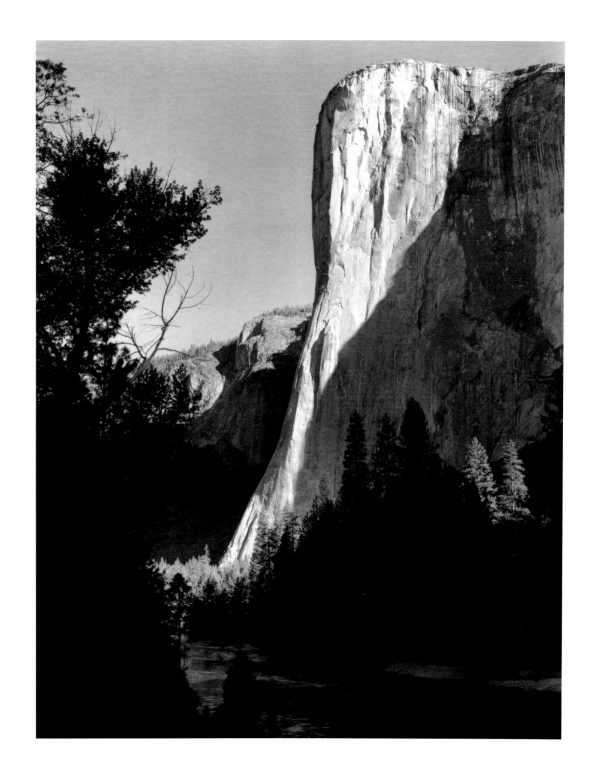

El Capitan, Sunrise, Yosemite National
Park, California, 1956

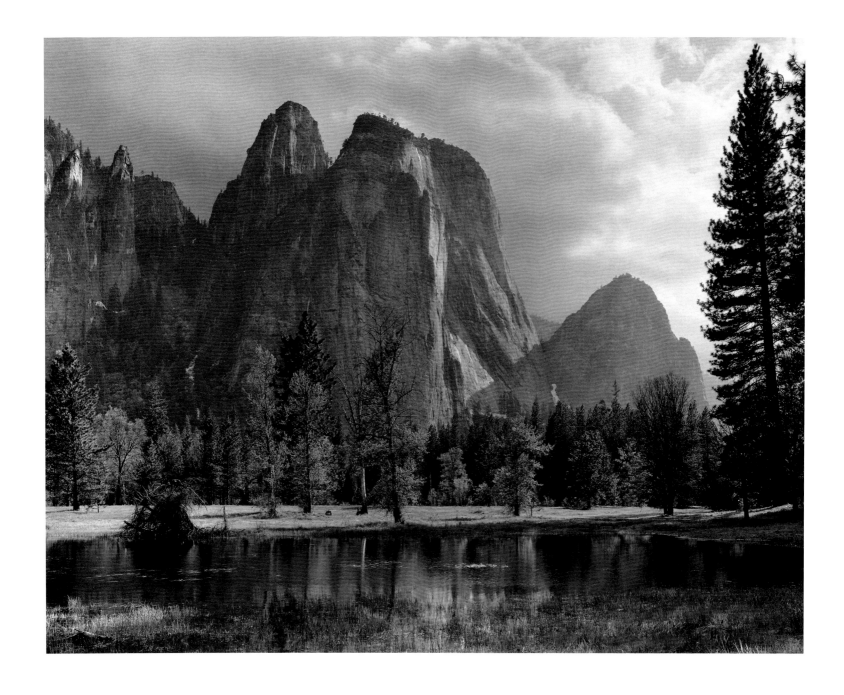

Cathedral Rocks, Yosemite National Park, California, c. 1949

MAY

6 MONDAY

a.m.

p.m.

7 TUESDAY

a.m.

p.m.

8 WEDNESDAY

a.m.

p.m.

9 THURSDAY

a.m.

p.m.

10 FRIDAY

a.m.

p.m.

11 SATURDAY

a.m.

12 SUNDAY

Mother's Day

MAY

S	M	T	W	T	F	S
			1	2	3	4
5	6	7	8	9	10	11
12	13	14	15	16	17	18
19	20	21	22	23	24	25
26	27	28	29	30	31	

APRIL

S	M	T	W	T	F	S
	1	2	3	4	5	6
7	8	9	10	11	12	13
14	15	16	17	18	19	20
21	22	23	24	25	26	27
28	29	30				

JUNE

S	M	T	W	T	F	S
						1
2	3	4	5	6	7	8
9	10	11	12	13	14	15
16	17	18	19	20	21	22
23	24	25	26	27	28	29
30						

MAY

13 MONDAY

a.m.

p.m.

14 TUESDAY

a.m.

p.m.

15 WEDNESDAY

a.m.

p.m.

16 THURSDAY

a.m.

p.m.

17 FRIDAY

a.m.

p.m.

18 SATURDAY

19 SUNDAY ◐

MAY

S	M	T	W	T	F	S
			1	2	3	4
5	6	7	8	9	10	11
12	13	14	15	16	17	18
19	20	21	22	23	24	25
26	27	28	29	30	31	

APRIL

S	M	T	W	T	F	S
	1	2	3	4	5	6
7	8	9	10	11	12	13
14	15	16	17	18	19	20
21	22	23	24	25	26	27
28	29	30				

JUNE

S	M	T	W	T	F	S
						1
2	3	4	5	6	7	8
9	10	11	12	13	14	15
16	17	18	19	20	21	22
23	24	25	26	27	28	29
30						

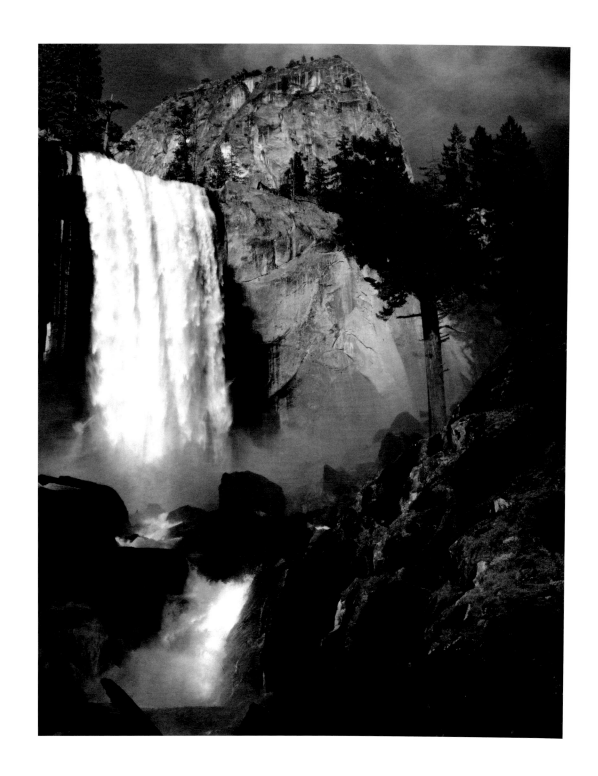

Vernal Fall, Yosemite National Park,
California, c. 1948

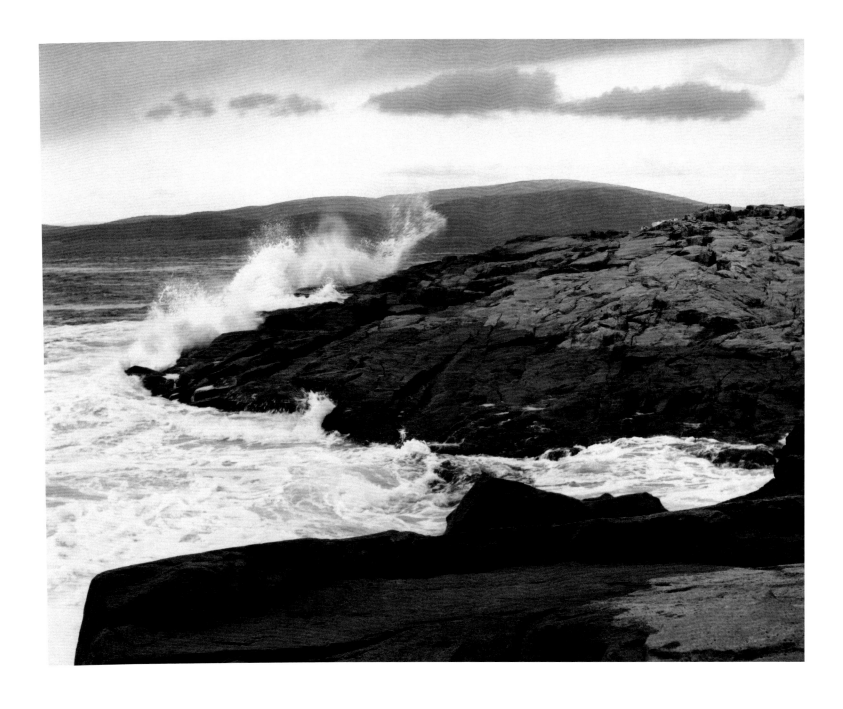

Sea and Rocks, Storm, Schoodic Point, Acadia National Park, Maine, 1949

MAY

20 MONDAY

a.m.

p.m.

Victoria Day (Canada)

21 TUESDAY

a.m.

p.m.

22 WEDNESDAY

a.m.

p.m.

23 THURSDAY

a.m.

p.m.

24 FRIDAY

a.m.

p.m.

25 SATURDAY

26 SUNDAY ○

MAY

S	M	T	W	T	F	S
			1	2	3	4
5	6	7	8	9	10	11
12	13	14	15	16	17	18
19	20	21	22	23	24	25
26	27	28	29	30	31	

APRIL

S	M	T	W	T	F	S
	1	2	3	4	5	6
7	8	9	10	11	12	13
14	15	16	17	18	19	20
21	22	23	24	25	26	27
28	29	30				

JUNE

S	M	T	W	T	F	S
						1
2	3	4	5	6	7	8
9	10	11	12	13	14	15
16	17	18	19	20	21	22
23	24	25	26	27	28	29
30						

MAY / JUNE

27 MONDAY

a.m.

p.m.

Memorial Day Observed

28 TUESDAY

a.m.

p.m.

29 WEDNESDAY

a.m.

p.m.

30 THURSDAY

a.m.

p.m.

31 FRIDAY

a.m.

p.m.

1 SATURDAY

2 SUNDAY

MAY

S	M	T	W	T	F	S
			1	2	3	4
5	6	7	8	9	10	11
12	13	14	15	16	17	18
19	20	21	22	23	24	25
26	27	28	29	30	31	

APRIL

S	M	T	W	T	F	S
	1	2	3	4	5	6
7	8	9	10	11	12	13
14	15	16	17	18	19	20
21	22	23	24	25	26	27
28	29	30				

JUNE

S	M	T	W	T	F	S
						1
2	3	4	5	6	7	8
9	10	11	12	13	14	15
16	17	18	19	20	21	22
23	24	25	26	27	28	29
30						

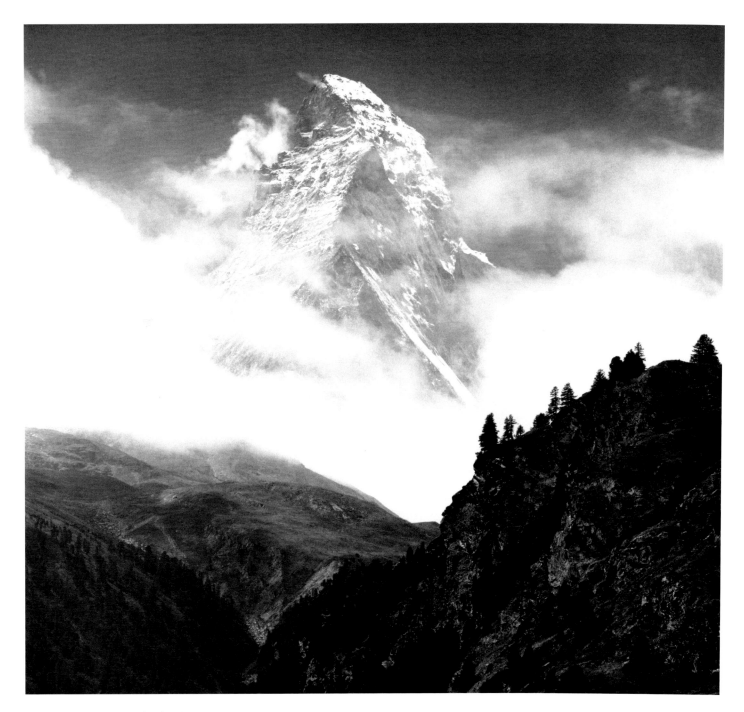

The Matterhorn, Switzerland, 1976

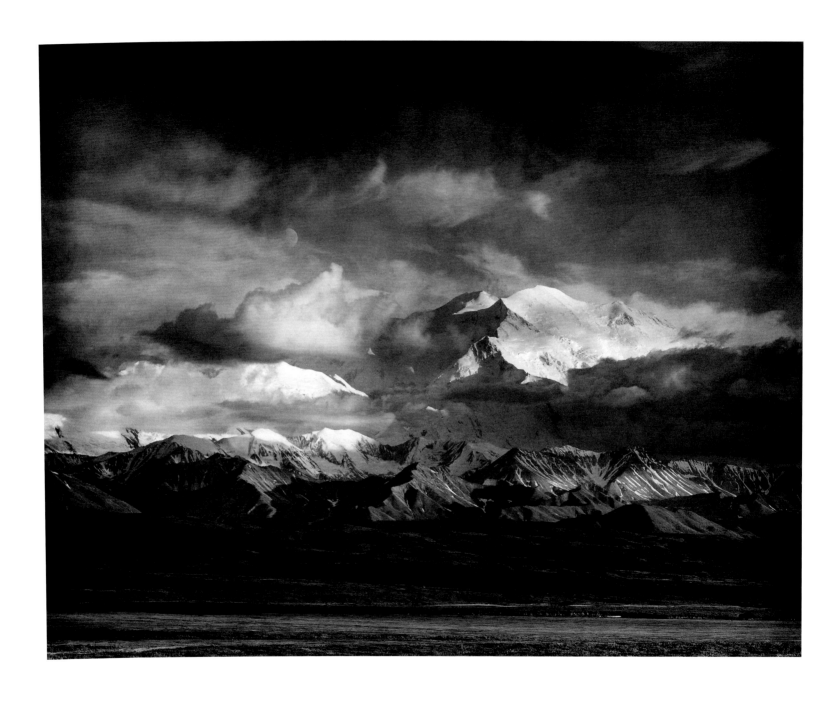

Moon and Mount McKinley, Denali National Park, Alaska, 1947

JUNE

3 MONDAY

a.m.

p.m.

4 TUESDAY

a.m.

p.m.

5 WEDNESDAY

a.m.

p.m.

6 THURSDAY

a.m.

p.m.

7 FRIDAY

a.m.

p.m.

8 SATURDAY

9 SUNDAY

JUNE

S	M	T	W	T	F	S
						1
2	3	4	5	6	7	8
9	10	11	12	13	14	15
16	17	18	19	20	21	22
23	24	25	26	27	28	29
30						

MAY

S	M	T	W	T	F	S
			1	2	3	4
5	6	7	8	9	10	11
12	13	14	15	16	17	18
19	20	21	22	23	24	25
26	27	28	29	30	31	

JULY

S	M	T	W	T	F	S
	1	2	3	4	5	6
7	8	9	10	11	12	13
14	15	16	17	18	19	20
21	22	23	24	25	26	27
28	29	30	31			

JUNE

10 MONDAY ●

a.m.

p.m.

11 TUESDAY

a.m.

p.m.

12 WEDNESDAY

a.m.

p.m.

13 THURSDAY

a.m.

p.m.

14 FRIDAY

a.m.

p.m.

Flag Day

15 SATURDAY

16 SUNDAY

Father's Day

JUNE

S	M	T	W	T	F	S
						1
2	3	4	5	6	7	8
9	10	11	12	13	14	15
16	17	18	19	20	21	22
23	24	25	26	27	28	29
30						

MAY

S	M	T	W	T	F	S
			1	2	3	4
5	6	7	8	9	10	11
12	13	14	15	16	17	18
19	20	21	22	23	24	25
26	27	28	29	30	31	

JULY

S	M	T	W	T	F	S
	1	2	3	4	5	6
7	8	9	10	11	12	13
14	15	16	17	18	19	20
21	22	23	24	25	26	27
28	29	30	31			

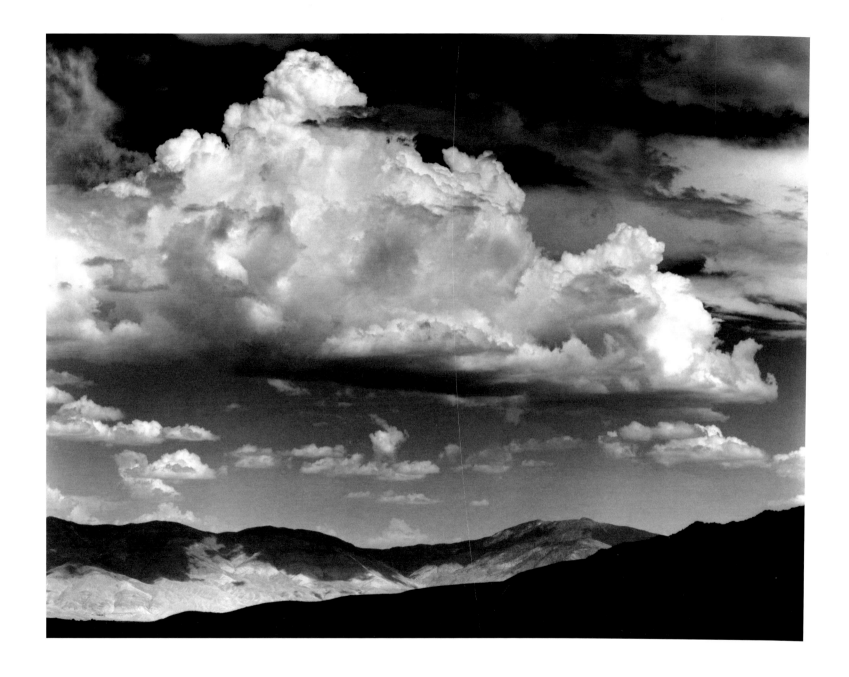

White Mountain Range, Thunderclouds, from the Buttermilk Country, near Bishop, California, 1959

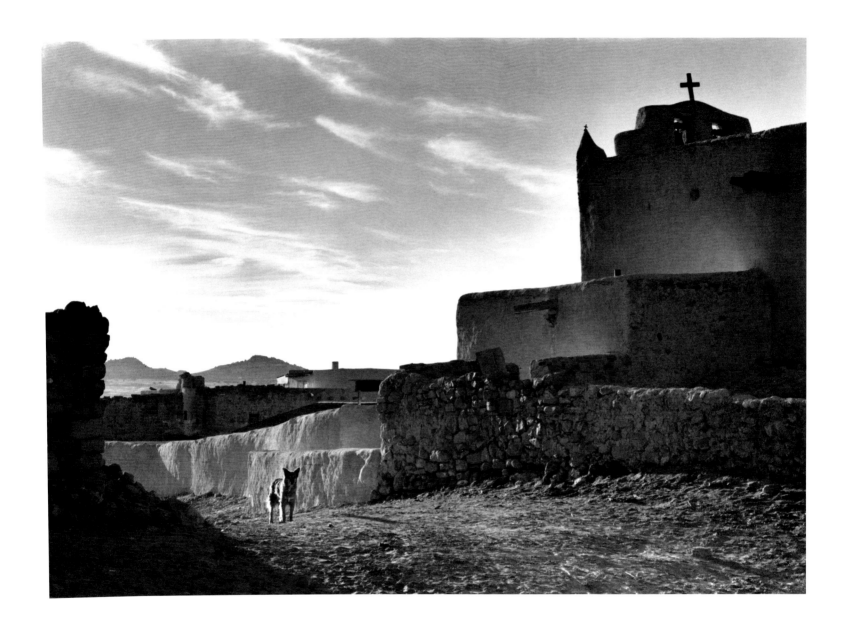

Sunrise, Laguna Pueblo, New Mexico, c. 1942

JUNE

17 MONDAY

a.m.

p.m.

18 TUESDAY

a.m.

p.m.

19 WEDNESDAY

a.m.

p.m.

20 THURSDAY

a.m.

p.m.

21 FRIDAY

a.m.

p.m.

Summer Solstice

22 SATURDAY

23 SUNDAY

JUNE

S	M	T	W	T	F	S
						1
2	3	4	5	6	7	8
9	10	11	12	13	14	15
16	17	18	19	20	21	22
23	24	25	26	27	28	29
30						

MAY

S	M	T	W	T	F	S
			1	2	3	4
5	6	7	8	9	10	11
12	13	14	15	16	17	18
19	20	21	22	23	24	25
26	27	28	29	30	31	

JULY

S	M	T	W	T	F	S
	1	2	3	4	5	6
7	8	9	10	11	12	13
14	15	16	17	18	19	20
21	22	23	24	25	26	27
28	29	30	31			

JUNE

24 MONDAY ○

a.m.

p.m.

25 TUESDAY

a.m.

p.m.

26 WEDNESDAY

a.m.

p.m.

27 THURSDAY

a.m.

p.m.

28 FRIDAY

a.m.

p.m.

29 SATURDAY

30 SUNDAY

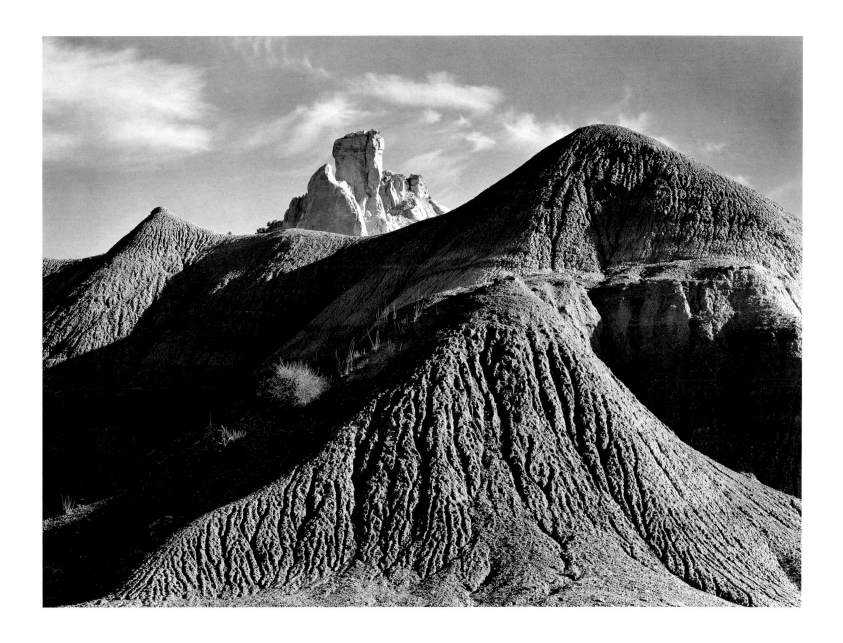

Ghost Ranch Hills, Chama Valley, Northern New Mexico, 1937

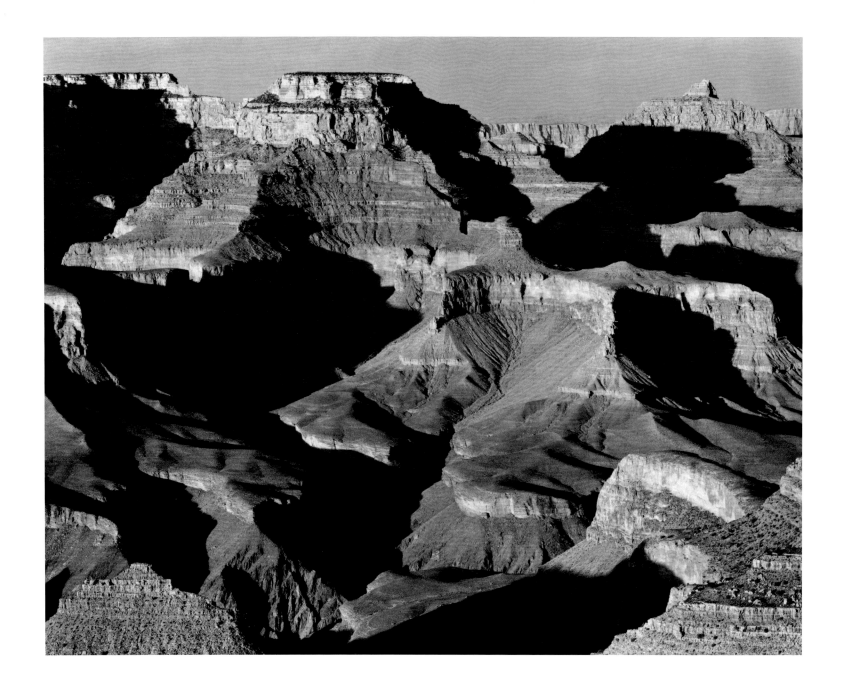

Cape Royal from the South Rim, Grand Canyon National Park, Arizona, c. 1947

JULY

1 MONDAY

a.m.

p.m.

Canada Day (Canada)

2 TUESDAY ◑

a.m.

p.m.

3 WEDNESDAY

a.m.

p.m.

4 THURSDAY

a.m.

p.m.

Independence Day

5 FRIDAY

a.m.

p.m.

6 SATURDAY

7 SUNDAY

JULY

S	M	T	W	T	F	S
	1	2	3	4	5	6
7	8	9	10	11	12	13
14	15	16	17	18	19	20
21	22	23	24	25	26	27
28	29	30	31			

JUNE

S	M	T	W	T	F	S
						1
2	3	4	5	6	7	8
9	10	11	12	13	14	15
16	17	18	19	20	21	22
23	24	25	26	27	28	29
30						

AUGUST

S	M	T	W	T	F	S
				1	2	3
4	5	6	7	8	9	10
11	12	13	14	15	16	17
18	19	20	21	22	23	24
25	26	27	28	29	30	31

JULY

8 MONDAY
a.m.

p.m.

9 TUESDAY
a.m.

p.m.

10 WEDNESDAY
a.m.

p.m.

11 THURSDAY
a.m.

p.m.

12 FRIDAY
a.m.

p.m.

13 SATURDAY

14 SUNDAY

JULY

S	M	T	W	T	F	S	
		1	2	3	4	5	6
7	8	9	10	11	12	13	
14	15	16	17	18	19	20	
21	22	23	24	25	26	27	
28	29	30	31				

JUNE

S	M	T	W	T	F	S
						1
2	3	4	5	6	7	8
9	10	11	12	13	14	15
16	17	18	19	20	21	22
23	24	25	26	27	28	29
30						

AUGUST

S	M	T	W	T	F	S
				1	2	3
4	5	6	7	8	9	10
11	12	13	14	15	16	17
18	19	20	21	22	23	24
25	26	27	28	29	30	31

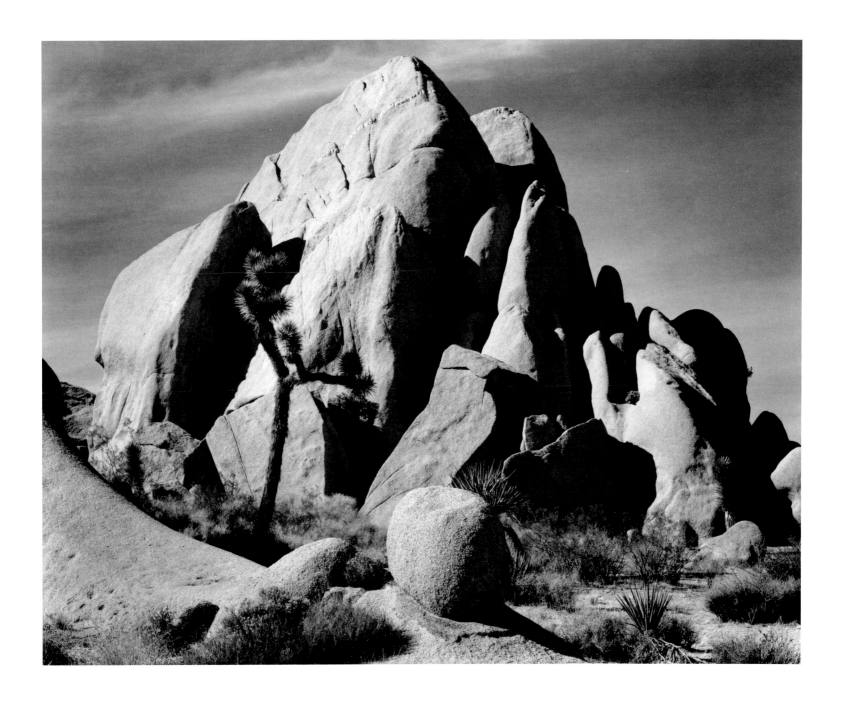

Rocks, Joshua Tree National Park, California, c. 1942

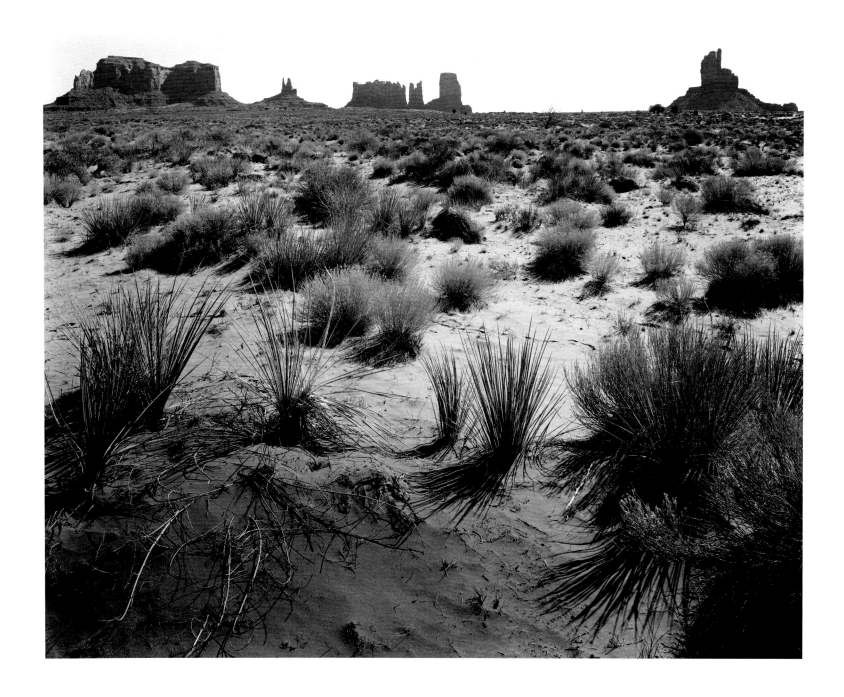

Monument Valley, Arizona, c. 1947

JULY

15 MONDAY

a.m.

p.m.

16 TUESDAY

a.m.

p.m.

17 WEDNESDAY ◐

a.m.

p.m.

18 THURSDAY

a.m.

p.m.

19 FRIDAY

a.m.

p.m.

20 SATURDAY

21 SUNDAY

JULY

S	M	T	W	T	F	S	
		1	2	3	4	5	6
7	8	9	10	11	12	13	
14	15	16	17	18	19	20	
21	22	23	24	25	26	27	
28	29	30	31				

JUNE

S	M	T	W	T	F	S
						1
2	3	4	5	6	7	8
9	10	11	12	13	14	15
16	17	18	19	20	21	22
23	24	25	26	27	28	29
30						

AUGUST

S	M	T	W	T	F	S
				1	2	3
4	5	6	7	8	9	10
11	12	13	14	15	16	17
18	19	20	21	22	23	24
25	26	27	28	29	30	31

JULY

22 MONDAY

a.m.

p.m.

23 TUESDAY

a.m.

p.m.

24 WEDNESDAY ○

a.m.

p.m.

25 THURSDAY

a.m.

p.m.

26 FRIDAY

a.m.

p.m.

27 SATURDAY

28 SUNDAY

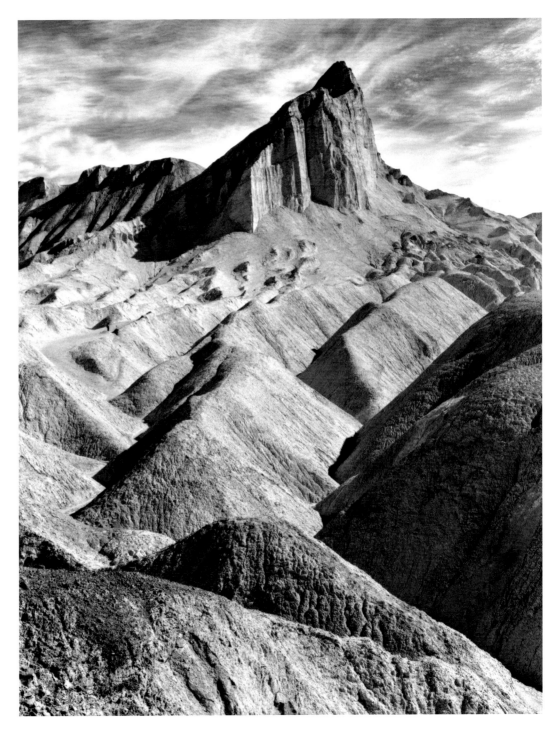

Manly Beacon, Death Valley National Park,
California, c. 1952

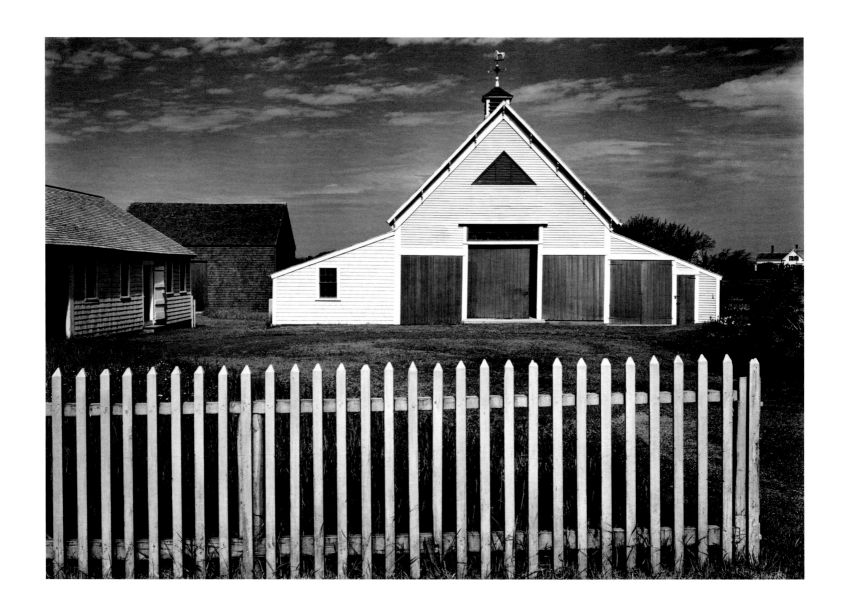

Barn, Cape Cod, Massachusetts, 1939

JULY/AUGUST

29 MONDAY
a.m.

p.m.

30 TUESDAY
a.m.

p.m.

31 WEDNESDAY
a.m.

p.m.

1 THURSDAY
a.m.

p.m.

2 FRIDAY
a.m.

p.m.

3 SATURDAY

4 SUNDAY

AUGUST

5 MONDAY

a.m.

p.m.

Civic Holiday (Canada)

6 TUESDAY

a.m.

p.m.

7 WEDNESDAY

a.m.

p.m.

8 THURSDAY ●

a.m.

p.m.

9 FRIDAY

a.m.

p.m.

10 SATURDAY

11 SUNDAY

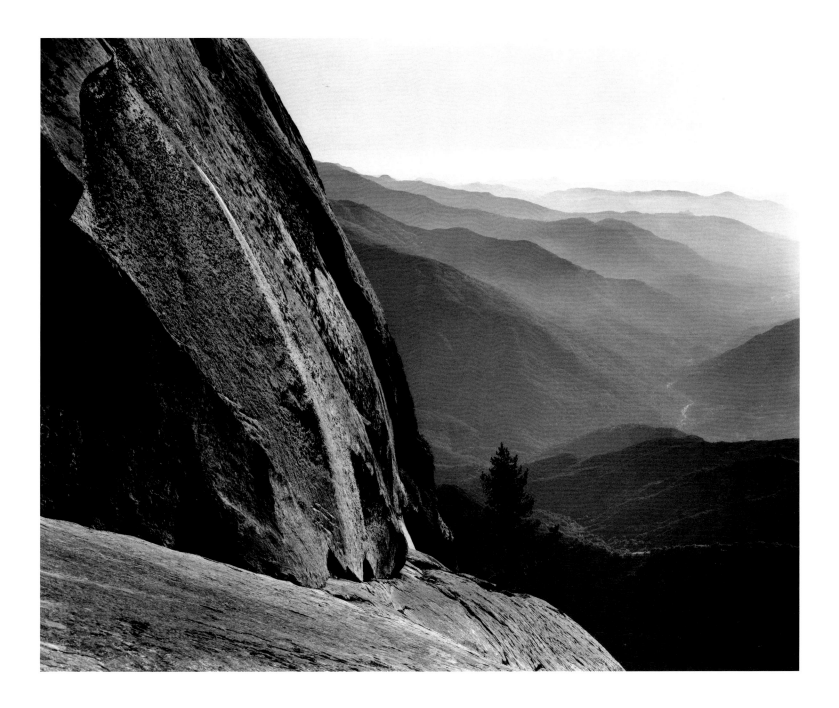

Moro Rock, Sequoia National Park, and Sierra Foothills, California, 1945

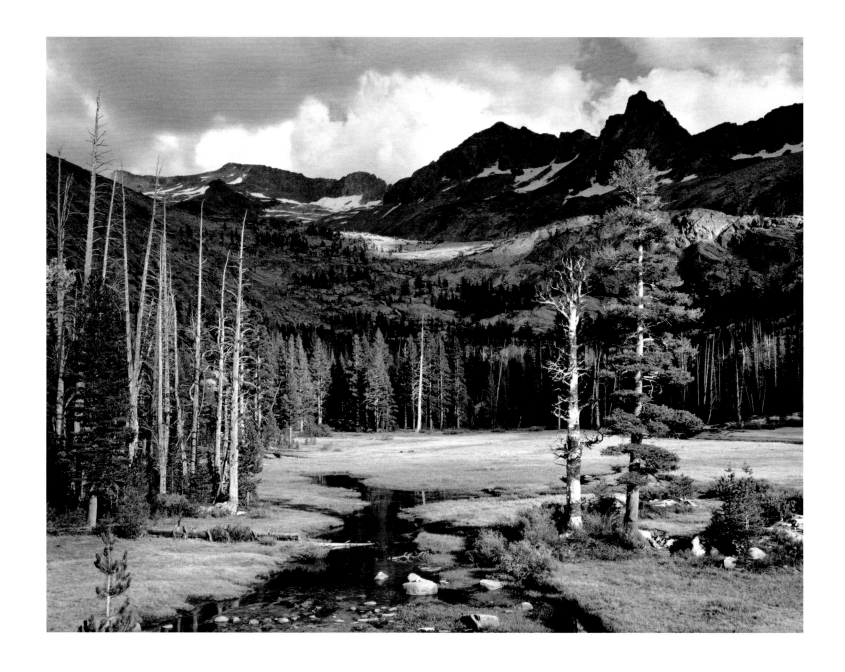

Mount Ansel Adams, Lyell Fork of the Merced River, Yosemite National Park, California, c. 1935

AUGUST

12 MONDAY

a.m.

p.m.

13 TUESDAY

a.m.

p.m.

14 WEDNESDAY

a.m.

p.m.

15 THURSDAY ◑

a.m.

p.m.

16 FRIDAY

a.m.

p.m.

17 SATURDAY

18 SUNDAY

AUGUST

S	M	T	W	T	F	S
				1	2	3
4	5	6	7	8	9	10
11	12	13	14	15	16	17
18	19	20	21	22	23	24
25	26	27	28	29	30	31

JULY

S	M	T	W	T	F	S
	1	2	3	4	5	6
7	8	9	10	11	12	13
14	15	16	17	18	19	20
21	22	23	24	25	26	27
28	29	30	31			

SEPTEMBER

S	M	T	W	T	F	S
1	2	3	4	5	6	7
8	9	10	11	12	13	14
15	16	17	18	19	20	21
22	23	24	25	26	27	28
29	30					

AUGUST

19 MONDAY

a.m.

p.m.

20 TUESDAY

a.m.

p.m.

21 WEDNESDAY

a.m.

p.m.

22 THURSDAY ○

a.m.

p.m.

23 FRIDAY

a.m.

p.m.

24 SATURDAY

25 SUNDAY

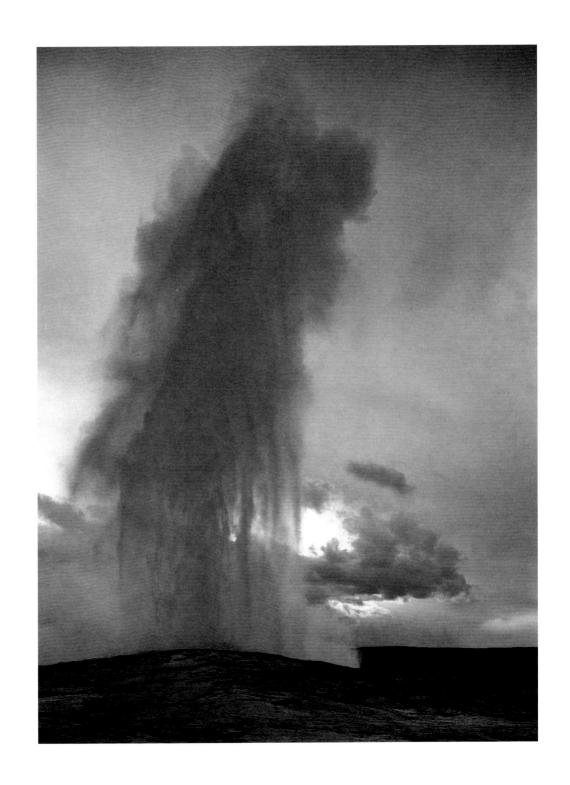

Old Faithful, Yellowstone National Park,
Wyoming, 1942

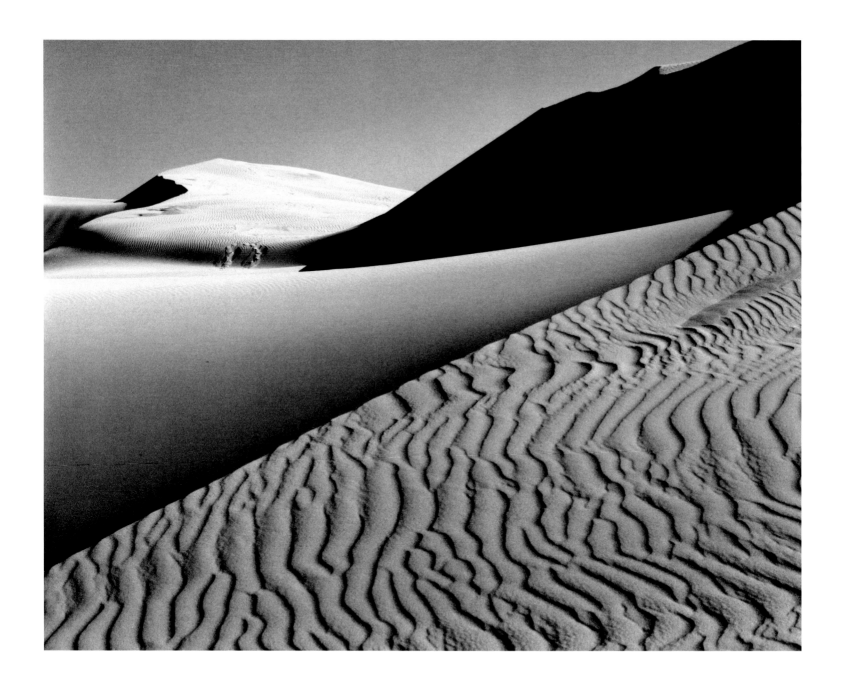

Dunes, Oceano, California, 1963

AUGUST/SEPTEMBER

26 MONDAY

a.m.

p.m.

27 TUESDAY

a.m.

p.m.

28 WEDNESDAY

a.m.

p.m.

29 THURSDAY

a.m.

p.m.

30 FRIDAY ◑

a.m.

p.m.

31 SATURDAY

1 SUNDAY

AUGUST

S	M	T	W	T	F	S	
					1	2	3
4	5	6	7	8	9	10	
11	12	13	14	15	16	17	
18	19	20	21	22	23	24	
25	26	27	28	29	30	31	

JULY

S	M	T	W	T	F	S
	1	2	3	4	5	6
7	8	9	10	11	12	13
14	15	16	17	18	19	20
21	22	23	24	25	26	27
28	29	30	31			

SEPTEMBER

S	M	T	W	T	F	S
1	2	3	4	5	6	7
8	9	10	11	12	13	14
15	16	17	18	19	20	21
22	23	24	25	26	27	28
29	30					

SEPTEMBER

2 MONDAY

a.m.

p.m.

Labor Day

3 TUESDAY

a.m.

p.m.

4 WEDNESDAY

a.m.

p.m.

5 THURSDAY

a.m.

p.m.

6 FRIDAY

a.m.

p.m.

7 SATURDAY

Rosh Hashanah

8 SUNDAY

SEPTEMBER
S	M	T	W	T	F	S
1	2	3	4	5	6	7
8	9	10	11	12	13	14
15	16	17	18	19	20	21
22	23	24	25	26	27	28
29	30					

AUGUST
S	M	T	W	T	F	S
				1	2	3
4	5	6	7	8	9	10
11	12	13	14	15	16	17
18	19	20	21	22	23	24
25	26	27	28	29	30	31

OCTOBER
S	M	T	W	T	F	S
		1	2	3	4	5
6	7	8	9	10	11	12
13	14	15	16	17	18	19
20	21	22	23	24	25	26
27	28	29	30	31		

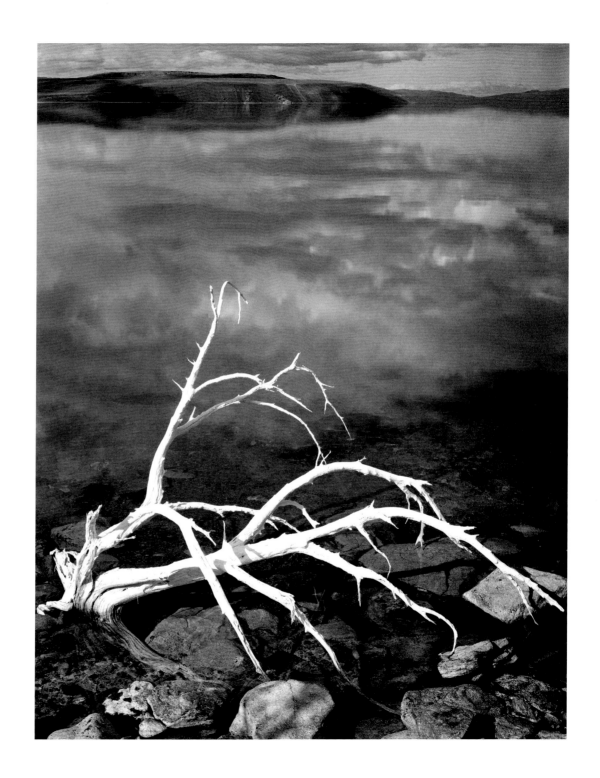

White Branches, Mono Lake,
California, 1950

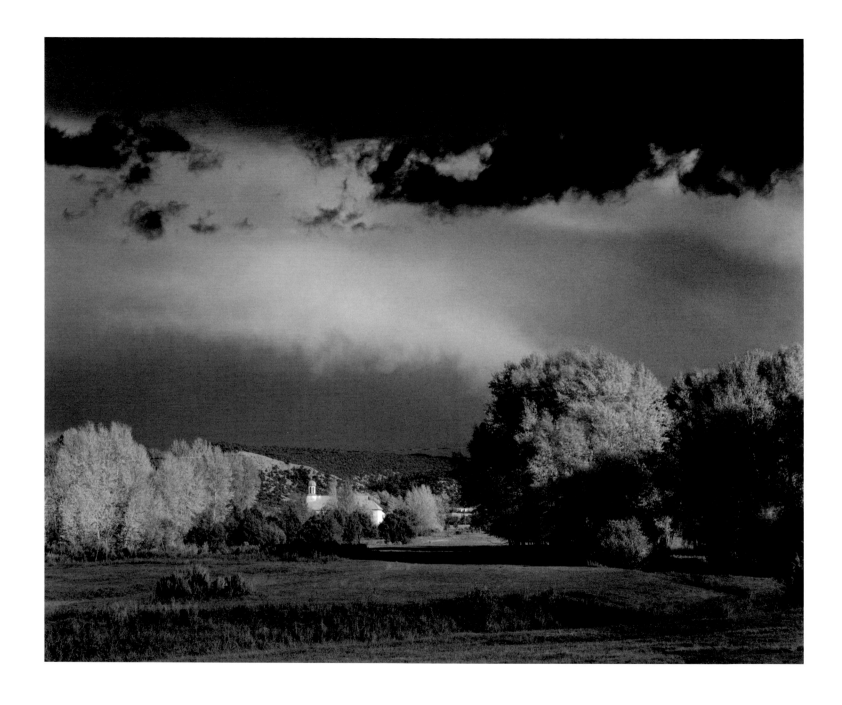

Autumn Storm, Los Trampas, near Penasco, New Mexico, c. 1958

SEPTEMBER

9 MONDAY

a.m.

p.m.

10 TUESDAY

a.m.

p.m.

11 WEDNESDAY

a.m.

p.m.

12 THURSDAY

a.m.

p.m.

13 FRIDAY

a.m.

p.m.

14 SATURDAY

15 SUNDAY

SEPTEMBER

S	M	T	W	T	F	S
1	2	3	4	5	6	7
8	9	10	11	12	13	14
15	16	17	18	19	20	21
22	23	24	25	26	27	28
29	30					

AUGUST

S	M	T	W	T	F	S
				1	2	3
4	5	6	7	8	9	10
11	12	13	14	15	16	17
18	19	20	21	22	23	24
25	26	27	28	29	30	31

OCTOBER

S	M	T	W	T	F	S
		1	2	3	4	5
6	7	8	9	10	11	12
13	14	15	16	17	18	19
20	21	22	23	24	25	26
27	28	29	30	31		

SEPTEMBER

16 MONDAY

a.m.

p.m.

Yom Kippur

17 TUESDAY

a.m.

p.m.

18 WEDNESDAY

a.m.

p.m.

19 THURSDAY

a.m.

p.m.

20 FRIDAY

a.m.

p.m.

21 SATURDAY ○

22 SUNDAY

SEPTEMBER

S	M	T	W	T	F	S
1	2	3	4	5	6	7
8	9	10	11	12	13	14
15	16	17	18	19	20	21
22	23	24	25	26	27	28
29	30					

AUGUST

S	M	T	W	T	F	S
				1	2	3
4	5	6	7	8	9	10
11	12	13	14	15	16	17
18	19	20	21	22	23	24
25	26	27	28	29	30	31

OCTOBER

S	M	T	W	T	F	S
		1	2	3	4	5
6	7	8	9	10	11	12
13	14	15	16	17	18	19
20	21	22	23	24	25	26
27	28	29	30	31		

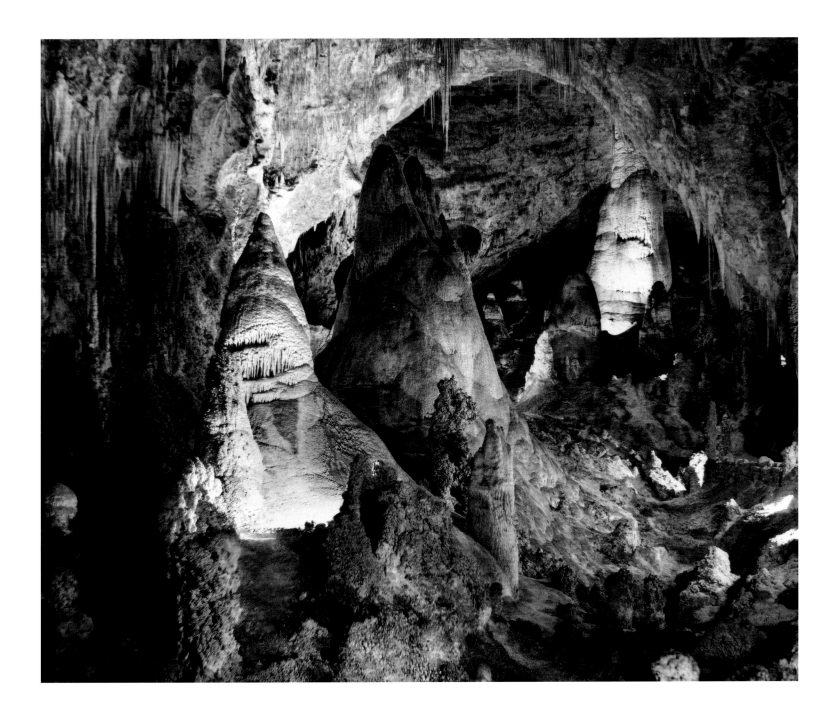

Big Room, Carlsbad Caverns National Park, New Mexico, 1942

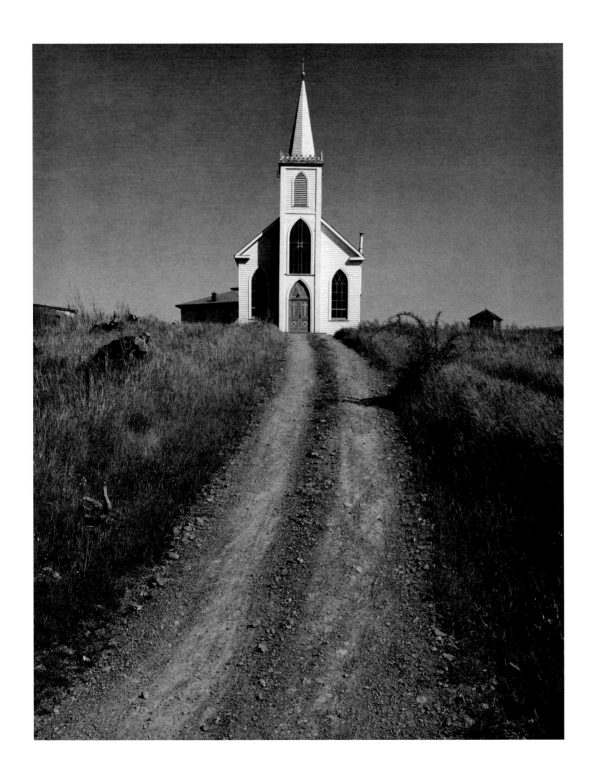

Church and Road, Bodega,
California, c. 1953

SEPTEMBER

23 MONDAY

a.m.

p.m.

Autumnal Equinox

24 TUESDAY

a.m.

p.m.

25 WEDNESDAY

a.m.

p.m.

26 THURSDAY

a.m.

p.m.

27 FRIDAY

a.m.

p.m.

28 SATURDAY

29 SUNDAY

SEPTEMBER/OCTOBER

30 MONDAY

a.m.

p.m.

1 TUESDAY

a.m.

p.m.

2 WEDNESDAY

a.m.

p.m.

3 THURSDAY

a.m.

p.m.

4 FRIDAY

a.m.

p.m.

5 SATURDAY

6 SUNDAY

Tree Fungus, Northern Cascades,
Washington, 1958

"Discussion on Art," San Francisco, California, c. 1936

OCTOBER

7 MONDAY

a.m.

p.m.

8 TUESDAY

a.m.

p.m.

9 WEDNESDAY

a.m.

p.m.

10 THURSDAY

a.m.

p.m.

11 FRIDAY

a.m.

p.m.

12 SATURDAY

13 SUNDAY ◗

OCTOBER

S	M	T	W	T	F	S
		1	2	3	4	5
6	7	8	9	10	11	12
13	14	15	16	17	18	19
20	21	22	23	24	25	26
27	28	29	30	31		

SEPTEMBER

S	M	T	W	T	F	S
1	2	3	4	5	6	7
8	9	10	11	12	13	14
15	16	17	18	19	20	21
22	23	24	25	26	27	28
29	30					

NOVEMBER

S	M	T	W	T	F	S
					1	2
3	4	5	6	7	8	9
10	11	12	13	14	15	16
17	18	19	20	21	22	23
24	25	26	27	28	29	30

OCTOBER

14 MONDAY

a.m.

p.m.

Columbus Day Observed

Thanksgiving Day (Canada)

15 TUESDAY

a.m.

p.m.

16 WEDNESDAY

a.m.

p.m.

17 THURSDAY

a.m.

p.m.

18 FRIDAY

a.m.

p.m.

19 SATURDAY

20 SUNDAY

OCTOBER

S	M	T	W	T	F	S
		1	2	3	4	5
6	7	8	9	10	11	12
13	14	15	16	17	18	19
20	21	22	23	24	25	26
27	28	29	30	31		

SEPTEMBER

S	M	T	W	T	F	S
1	2	3	4	5	6	7
8	9	10	11	12	13	14
15	16	17	18	19	20	21
22	23	24	25	26	27	28
29	30					

NOVEMBER

S	M	T	W	T	F	S
					1	2
3	4	5	6	7	8	9
10	11	12	13	14	15	16
17	18	19	20	21	22	23
24	25	26	27	28	29	30

Redwoods, Bull Creek Flat, Northern California, c. 1960

Winnowing Grain, Taos Pueblo,
New Mexico, c. 1929

OCTOBER

21 MONDAY ○

a.m.

p.m.

22 TUESDAY

a.m.

p.m.

23 WEDNESDAY

a.m.

p.m.

24 THURSDAY

a.m.

p.m.

25 FRIDAY

a.m.

p.m.

26 SATURDAY

27 SUNDAY

Daylight Saving Time ends

OCTOBER

S	M	T	W	T	F	S
		1	2	3	4	5
6	7	8	9	10	11	12
13	14	15	16	17	18	19
20	21	22	23	24	25	26
27	28	29	30	31		

SEPTEMBER

S	M	T	W	T	F	S
1	2	3	4	5	6	7
8	9	10	11	12	13	14
15	16	17	18	19	20	21
22	23	24	25	26	27	28
29	30					

NOVEMBER

S	M	T	W	T	F	S
					1	2
3	4	5	6	7	8	9
10	11	12	13	14	15	16
17	18	19	20	21	22	23
24	25	26	27	28	29	30

OCTOBER/NOVEMBER

28 MONDAY
a.m.

p.m.

29 TUESDAY ◐
a.m.

p.m.

30 WEDNESDAY
a.m.

p.m.

31 THURSDAY
a.m.

p.m.

Halloween

1 FRIDAY
a.m.

p.m.

2 SATURDAY

3 SUNDAY

OCTOBER

S	M	T	W	T	F	S	
			1	2	3	4	5
6	7	8	9	10	11	12	
13	14	15	16	17	18	19	
20	21	22	23	24	25	26	
27	28	29	30	31			

SEPTEMBER

S	M	T	W	T	F	S
1	2	3	4	5	6	7
8	9	10	11	12	13	14
15	16	17	18	19	20	21
22	23	24	25	26	27	28
29	30					

NOVEMBER

S	M	T	W	T	F	S
					1	2
3	4	5	6	7	8	9
10	11	12	13	14	15	16
17	18	19	20	21	22	23
24	25	26	27	28	29	30

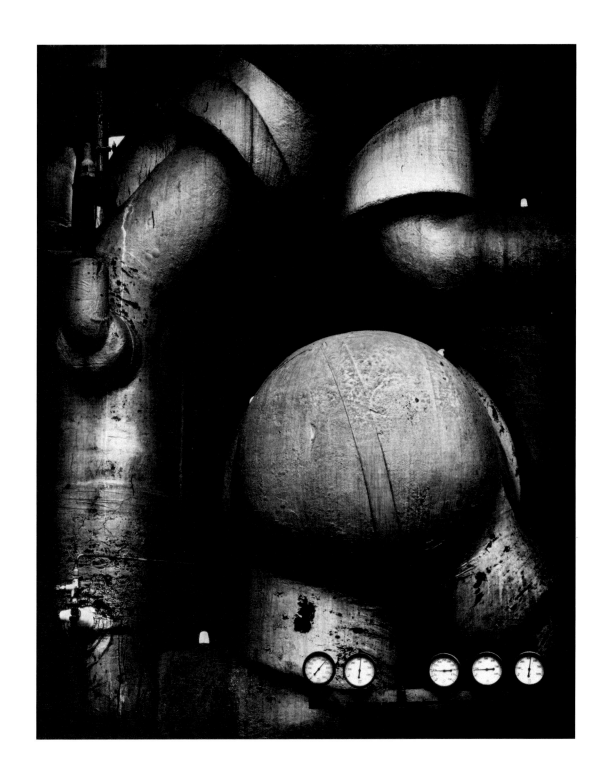

Pipes and Gauges, Charlestown,
West Virginia, 1939

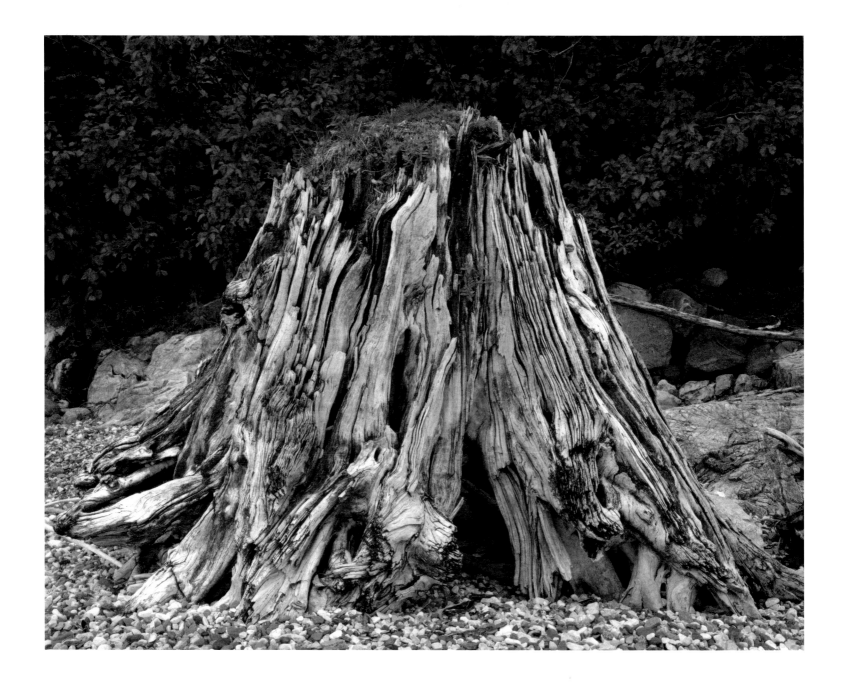

Stump, Interstidial Forest, Glacier Bay National Monument, Alaska, c. 1948

NOVEMBER

4 MONDAY ●

a.m.

p.m.

5 TUESDAY

a.m.

p.m.

Election Day

6 WEDNESDAY

a.m.

p.m.

7 THURSDAY

a.m.

p.m.

8 FRIDAY

a.m.

p.m.

9 SATURDAY

10 SUNDAY

NOVEMBER

S	M	T	W	T	F	S
					1	2
3	4	5	6	7	8	9
10	11	12	13	14	15	16
17	18	19	20	21	22	23
24	25	26	27	28	29	30

OCTOBER

S	M	T	W	T	F	S
		1	2	3	4	5
6	7	8	9	10	11	12
13	14	15	16	17	18	19
20	21	22	23	24	25	26
27	28	29	30	31		

DECEMBER

S	M	T	W	T	F	S
1	2	3	4	5	6	7
8	9	10	11	12	13	14
15	16	17	18	19	20	21
22	23	24	25	26	27	28
29	30	31				

NOVEMBER

11 MONDAY ◑

a.m.

p.m.

Veterans Day

Remembrance Day (Canada)

12 TUESDAY

a.m.

p.m.

13 WEDNESDAY

a.m.

p.m.

14 THURSDAY

a.m.

p.m.

15 FRIDAY

a.m.

p.m.

16 SATURDAY

17 SUNDAY

NOVEMBER

S	M	T	W	T	F	S
					1	2
3	4	5	6	7	8	9
10	11	12	13	14	15	16
17	18	19	20	21	22	23
24	25	26	27	28	29	30

OCTOBER

S	M	T	W	T	F	S
		1	2	3	4	5
6	7	8	9	10	11	12
13	14	15	16	17	18	19
20	21	22	23	24	25	26
27	28	29	30	31		

DECEMBER

S	M	T	W	T	F	S
1	2	3	4	5	6	7
8	9	10	11	12	13	14
15	16	17	18	19	20	21
22	23	24	25	26	27	28
29	30	31				

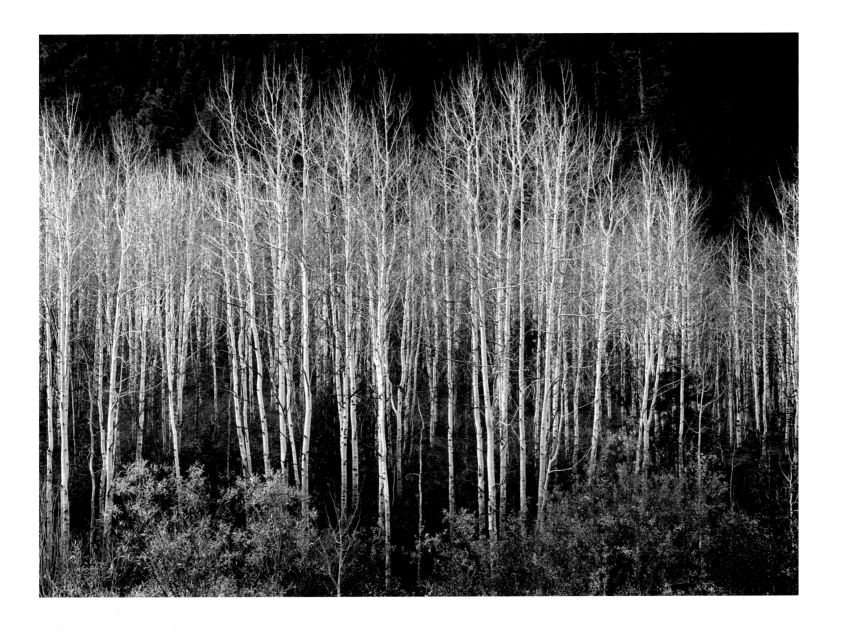

Aspens, Dawn, Dolores River Canyon, Autumn, Colorado, 1937

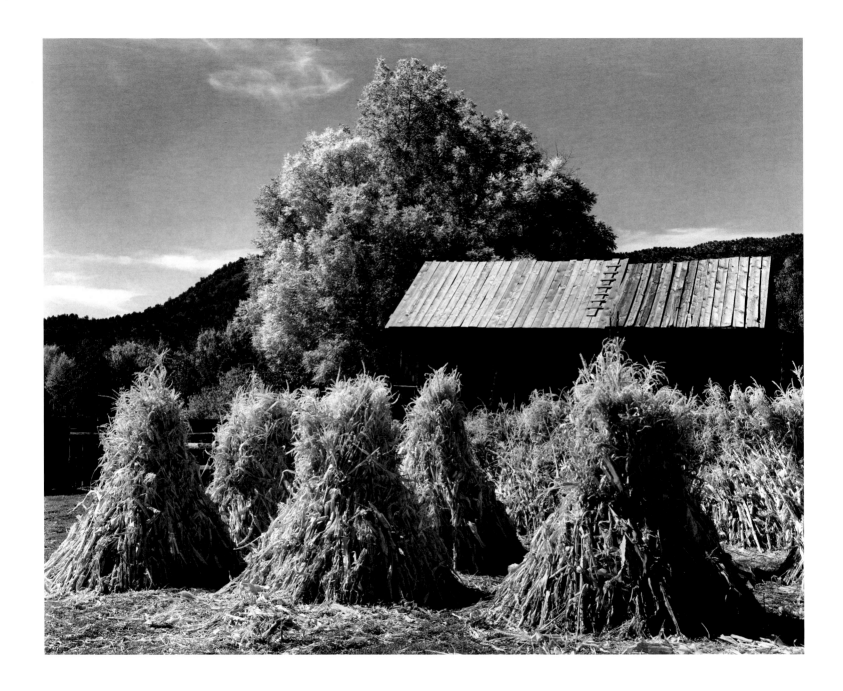

Farm, Autumn, Southern Utah, c. 1940

NOVEMBER

18 MONDAY

a.m.

p.m.

19 TUESDAY ○

a.m.

p.m.

20 WEDNESDAY

a.m.

p.m.

21 THURSDAY

a.m.

p.m.

22 FRIDAY

a.m.

p.m.

23 SATURDAY

24 SUNDAY

NOVEMBER

S	M	T	W	T	F	S
					1	2
3	4	5	6	7	8	9
10	11	12	13	14	15	16
17	18	19	20	21	22	23
24	25	26	27	28	29	30

OCTOBER

S	M	T	W	T	F	S
		1	2	3	4	5
6	7	8	9	10	11	12
13	14	15	16	17	18	19
20	21	22	23	24	25	26
27	28	29	30	31		

DECEMBER

S	M	T	W	T	F	S
1	2	3	4	5	6	7
8	9	10	11	12	13	14
15	16	17	18	19	20	21
22	23	24	25	26	27	28
29	30	31				

NOVEMBER/DECEMBER

25 MONDAY
a.m.

p.m.

26 TUESDAY
a.m.

p.m.

27 WEDNESDAY
a.m.

p.m.

28 THURSDAY
a.m.

p.m.

Thanksgiving Day

29 FRIDAY
a.m.

p.m.

30 SATURDAY

Hanukkah

1 SUNDAY

NOVEMBER

S	M	T	W	T	F	S
					1	2
3	4	5	6	7	8	9
10	11	12	13	14	15	16
17	18	19	20	21	22	23
24	25	26	27	28	29	30

OCTOBER

S	M	T	W	T	F	S
		1	2	3	4	5
6	7	8	9	10	11	12
13	14	15	16	17	18	19
20	21	22	23	24	25	26
27	28	29	30	31		

DECEMBER

S	M	T	W	T	F	S
1	2	3	4	5	6	7
8	9	10	11	12	13	14
15	16	17	18	19	20	21
22	23	24	25	26	27	28
29	30	31				

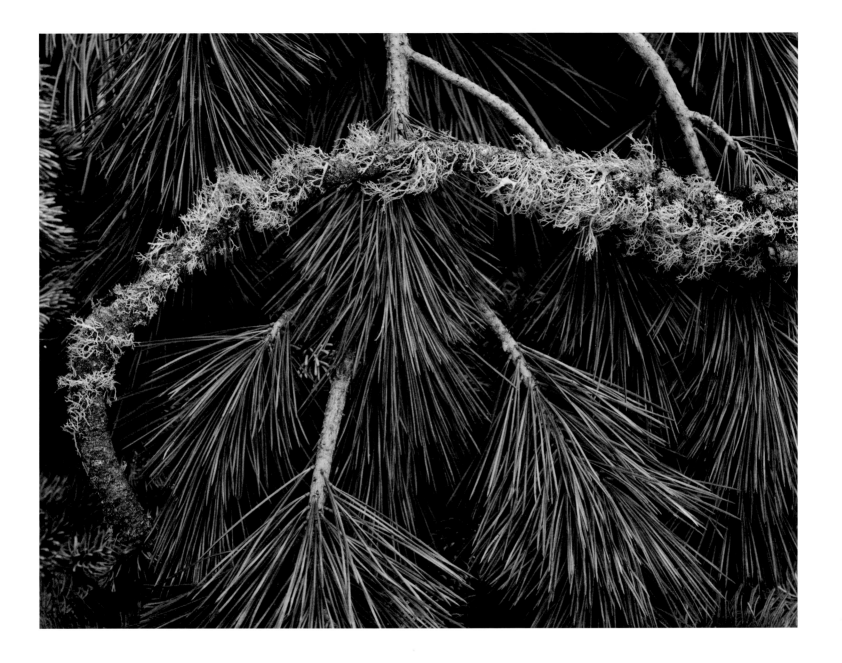

Sugar Pine Boughs and Lichen, Yosemite National Park, California, 1962

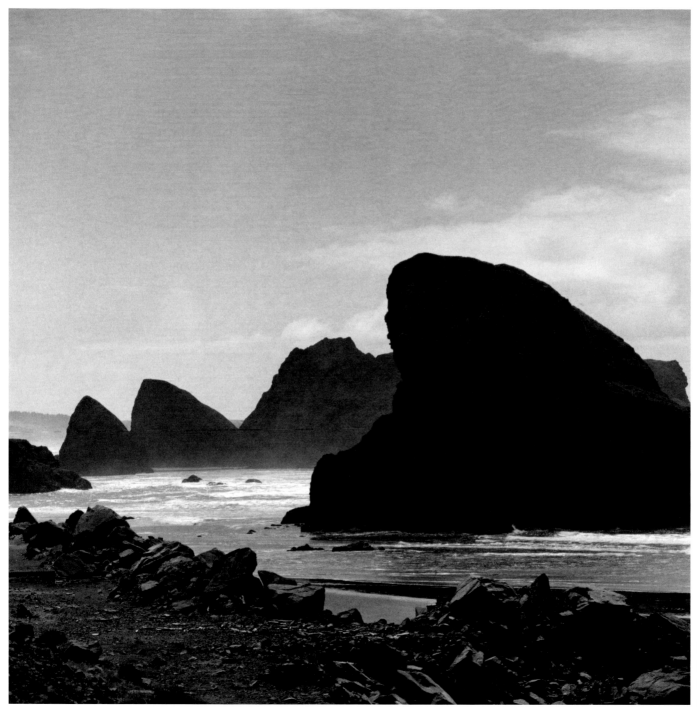

Oregon Coast,
South of Cape
Sebastian,
c. 1968

DECEMBER

2 MONDAY

a.m.

p.m.

3 TUESDAY

a.m.

p.m.

4 WEDNESDAY ●

a.m.

p.m.

5 THURSDAY

a.m.

p.m.

6 FRIDAY

a.m.

p.m.

7 SATURDAY

8 SUNDAY

DECEMBER

S	M	T	W	T	F	S	
	1	2	3	4	5	6	7
8	9	10	11	12	13	14	
15	16	17	18	19	20	21	
22	23	24	25	26	27	28	
29	30	31					

NOVEMBER

S	M	T	W	T	F	S
					1	2
3	4	5	6	7	8	9
10	11	12	13	14	15	16
17	18	19	20	21	22	23
24	25	26	27	28	29	30

JANUARY

S	M	T	W	T	F	S
			1	2	3	4
5	6	7	8	9	10	11
12	13	14	15	16	17	18
19	20	21	22	23	24	25
26	27	28	29	30	31	

DECEMBER

9 MONDAY

a.m.

p.m.

Hanukkah

10 TUESDAY

a.m.

p.m.

11 WEDNESDAY ◗

a.m.

p.m.

12 THURSDAY

a.m.

p.m.

13 FRIDAY

a.m.

p.m.

14 SATURDAY

15 SUNDAY

DECEMBER

S	M	T	W	T	F	S	
	1	2	3	4	5	6	7
8	9	10	11	12	13	14	
15	16	17	18	19	20	21	
22	23	24	25	26	27	28	
29	30	31					

NOVEMBER

S	M	T	W	T	F	S
					1	2
3	4	5	6	7	8	9
10	11	12	13	14	15	16
17	18	19	20	21	22	23
24	25	26	27	28	29	30

JANUARY

S	M	T	W	T	F	S
			1	2	3	4
5	6	7	8	9	10	11
12	13	14	15	16	17	18
19	20	21	22	23	24	25
26	27	28	29	30	31	

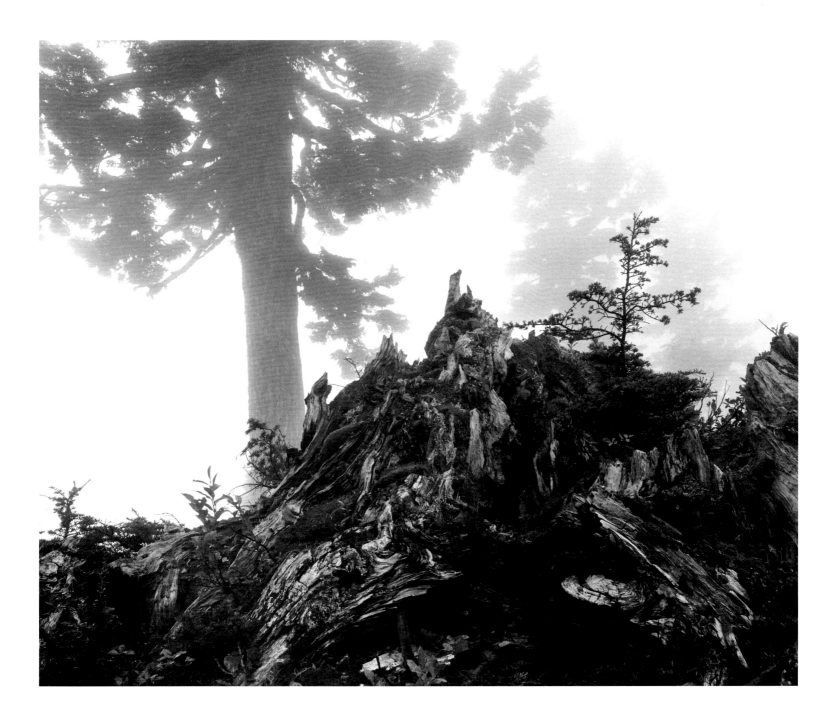

Tree, Stump, Mist, Northern Cascades, Washington, 1958

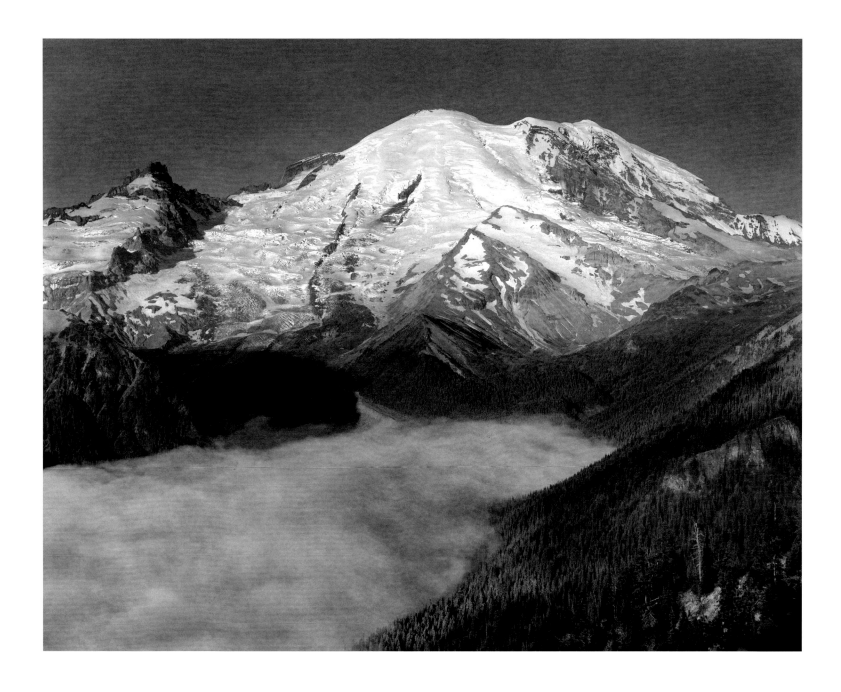

Mount Rainier, Sunrise, Mount Rainier National Park, Washington, c. 1950

DECEMBER

16 MONDAY

a.m.

p.m.

17 TUESDAY

a.m.

p.m.

18 WEDNESDAY

a.m.

p.m.

19 THURSDAY ○

a.m.

p.m.

20 FRIDAY

a.m.

p.m.

21 SATURDAY

Winter Solstice

22 SUNDAY

DECEMBER

S	M	T	W	T	F	S
1	2	3	4	5	6	7
8	9	10	11	12	13	14
15	16	17	18	19	20	21
22	23	24	25	26	27	28
29	30	31				

NOVEMBER

S	M	T	W	T	F	S
					1	2
3	4	5	6	7	8	9
10	11	12	13	14	15	16
17	18	19	20	21	22	23
24	25	26	27	28	29	30

JANUARY

S	M	T	W	T	F	S
			1	2	3	4
5	6	7	8	9	10	11
12	13	14	15	16	17	18
19	20	21	22	23	24	25
26	27	28	29	30	31	

DECEMBER

23 MONDAY
a.m.

p.m.

24 TUESDAY
a.m.

p.m.

25 WEDNESDAY
a.m.

p.m.

Christmas

26 THURSDAY ◐
a.m.

p.m.

Boxing Day (Canada)

27 FRIDAY
a.m.

p.m.

28 SATURDAY

29 SUNDAY

DECEMBER

S	M	T	W	T	F	S
1	2	3	4	5	6	7
8	9	10	11	12	13	14
15	16	17	18	19	20	21
22	23	24	25	26	27	28
29	30	31				

NOVEMBER

S	M	T	W	T	F	S
					1	2
3	4	5	6	7	8	9
10	11	12	13	14	15	16
17	18	19	20	21	22	23
24	25	26	27	28	29	30

JANUARY

S	M	T	W	T	F	S
			1	2	3	4
5	6	7	8	9	10	11
12	13	14	15	16	17	18
19	20	21	22	23	24	25
26	27	28	29	30	31	

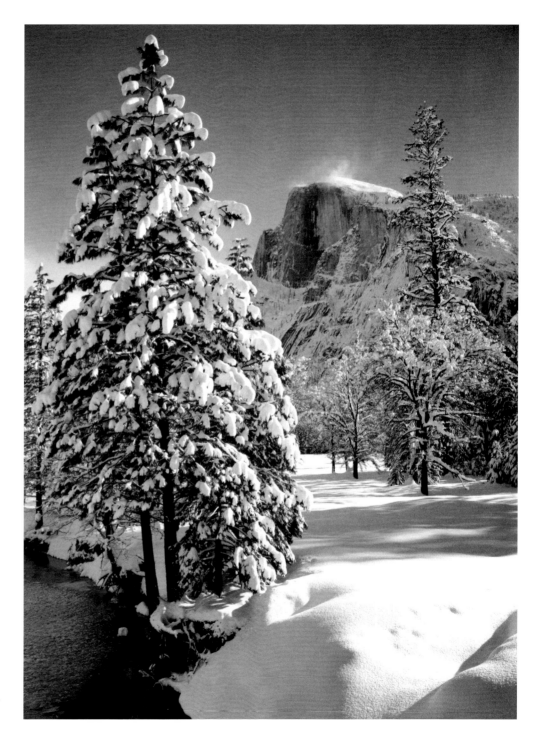

Half Dome, Tree, Winter, from Stoneman Bridge,

Yosemite National Park, California, c. 1940

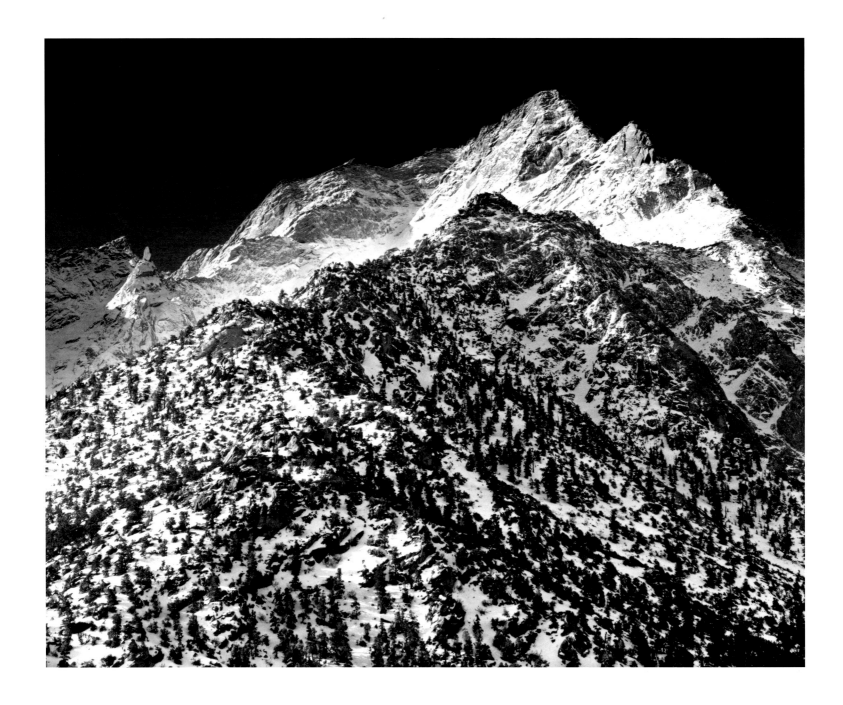

Lone Pine Peak, Winter, Sunrise, Sierra Nevada, California, 1948

DECEMBER/JANUARY 2003

30 MONDAY

a.m.

p.m.

31 TUESDAY

a.m.

p.m.

1 WEDNESDAY

a.m.

p.m.

New Year's Day

2 THURSDAY ●

a.m.

p.m.

3 FRIDAY

a.m.

p.m.

4 SATURDAY

5 SUNDAY

DECEMBER

S	M	T	W	T	F	S
1	2	3	4	5	6	7
8	9	10	11	12	13	14
15	16	17	18	19	20	21
22	23	24	25	26	27	28
29	30	31				

NOVEMBER

S	M	T	W	T	F	S
					1	2
3	4	5	6	7	8	9
10	11	12	13	14	15	16
17	18	19	20	21	22	23
24	25	26	27	28	29	30

JANUARY

S	M	T	W	T	F	S
			1	2	3	4
5	6	7	8	9	10	11
12	13	14	15	16	17	18
19	20	21	22	23	24	25
26	27	28	29	30	31	

JANUARY 2002

MONDAY	TUESDAY	WEDNESDAY	THURSDAY	FRIDAY	SAT/SUN
	1 New Year's Day	**2**	**3**	**4**	**5 / 6**
7	**8**	**9**	**10**	**11**	**12 / 13**
14	**15**	**16**	**17**	**18**	**19 / 20**
21 Martin Luther King Jr. Day	**22**	**23**	**24**	**25**	**26 / 27**
28	**29**	**30**	**31**		

FEBRUARY 2002

MONDAY	TUESDAY	WEDNESDAY	THURSDAY	FRIDAY	SAT/SUN
				1	2 / 3
4	5	6	7	8	9 / 10
11	12 Chinese New Year Lincoln's Birthday	13 Ash Wednesday	14 Valentine's Day	15	16 / 17
18 Presidents' Day	19	20	21	22 Washington's Birthday	23 / 24
25	26	27	28		

MARCH 2002

MONDAY	TUESDAY	WEDNESDAY	THURSDAY	FRIDAY	SAT/SUN
				1	2 / 3
4	5	6	7	8	9 / 10
11	12	13	14	15	16 / 17 17 St. Patrick's Day
18	19	20 Vernal Equinox	21	22	23 / 24 24 Palm Sunday
25	26	27	28 Passover	29 Good Friday	30
31 Easter Sunday					

APRIL 2002

MONDAY	TUESDAY	WEDNESDAY	THURSDAY	FRIDAY	SAT/SUN
1 Easter Monday (Canada)	**2**	**3**	**4**	**5**	**6 / 7** 7 Daylight Saving Time begins
8	**9**	**10**	**11**	**12**	**13 / 14**
15	**16**	**17**	**18**	**19**	**20 / 21**
22	**23**	**24**	**25**	**26**	**27 / 28**
29	**30**				

MAY 2002

MONDAY	TUESDAY	WEDNESDAY	THURSDAY	FRIDAY	SAT/SUN
		1	2	3	4 / 5
6	7	8	9	10	11 / 12 12 Mother's Day
13	14	15	16	17	18 / 19
20 Victoria Day (Canada)	21	22	23	24	25 / 26
27 Memorial Day Observed	28	29	30	31	

JUNE 2002

MONDAY	TUESDAY	WEDNESDAY	THURSDAY	FRIDAY	SAT/SUN
					1 / 2
3	4	5	6	7	8 / 9
10	11	12	13	14 Flag Day	15 / 16 16 Father's Day
17	18	19	20	21 Summer Solstice	22 / 23
24	25	26	27	28	29 / 30

JULY 2002

MONDAY	TUESDAY	WEDNESDAY	THURSDAY	FRIDAY	SAT/SUN
1 Canada Day (Canada)	**2**	**3**	**4** Independence Day	**5**	**6 / 7**
8	**9**	**10**	**11**	**12**	**13 / 14**
15	**16**	**17**	**18**	**19**	**20 / 21**
22	**23**	**24**	**25**	**26**	**27 / 28**
29	**30**	**31**			

AUGUST 2002

MONDAY	TUESDAY	WEDNESDAY	THURSDAY	FRIDAY	SAT/SUN
			1	2	3 / 4
5 Civic Holiday (Canada)	6	7	8	9	10 / 11
12	13	14	15	16	17 / 18
19	20	21	22	23	24 / 25
26	27	28	29	30	31

SEPTEMBER 2002

MONDAY	TUESDAY	WEDNESDAY	THURSDAY	FRIDAY	SAT/SUN
					1
2 Labor Day	**3**	**4**	**5**	**6**	**7 / 8** 7 Rosh Hashanah
9	**10**	**11**	**12**	**13**	**14 / 15**
16 Yom Kippur	**17**	**18**	**19**	**20**	**21 / 22**
23 Autumnal Equinox	**24**	**25**	**26**	**27**	**28 / 29**
30					

OCTOBER 2002

MONDAY	TUESDAY	WEDNESDAY	THURSDAY	FRIDAY	SAT/SUN
	1	2	3	4	5 / 6
7	8	9	10	11	12 / 13
14 Columbus Day Observed Thanksgiving Day (Canada)	15	16	17	18	19 / 20
21	22	23	24	25	26 / 27 27 Daylight Saving Time ends
28	29	30	31 Halloween		

NOVEMBER 2002

MONDAY	TUESDAY	WEDNESDAY	THURSDAY	FRIDAY	SAT/SUN
				1	**2 / 3**
4	**5** Election Day	**6**	**7**	**8**	**9 / 10**
11 Veterans Day Remembrance Day (Canada)	**12**	**13**	**14**	**15**	**16 / 17**
18	**19**	**20**	**21**	**22**	**23 / 24**
25	**26**	**27**	**28** Thanksgiving Day	**29**	**30** Hanukkah

DECEMBER 2002

MONDAY	TUESDAY	WEDNESDAY	THURSDAY	FRIDAY	SAT/SUN
					1
2	**3**	**4**	**5**	**6**	**7 / 8**
9	**10**	**11**	**12**	**13**	**14 / 15**
16	**17**	**18**	**19**	**20**	**21 / 22** 21 Winter Solstice
23	**24**	**25** Christmas	**26** Boxing Day (Canada)	**27**	**28 / 29**
30	**31**				

JANUARY 2003

MONDAY	TUESDAY	WEDNESDAY	THURSDAY	FRIDAY	SAT/SUN
		1 New Year's Day	**2**	**3**	**4 / 5**
6	**7**	**8**	**9**	**10**	**11 / 12**
13	**14**	**15**	**16**	**17**	**18 / 19**
20 Martin Luther King Jr. Day	**21**	**22**	**23**	**24**	**25 / 26**
27	**28**	**29**	**30**	**31**	

FEBRUARY 2003

MONDAY	TUESDAY	WEDNESDAY	THURSDAY	FRIDAY	SAT/SUN
					1 / 2 1 Chinese New Year
3	**4**	**5**	**6**	**7**	**8 / 9**
10	**11**	**12** Lincoln's Birthday	**13**	**14** Valentine's Day	**15 / 16**
17 Presidents' Day	**18**	**19**	**20**	**21**	**22 / 23** 22 Washington's Birthday
24	**25**	**26**	**27**	**28**	

2002

JANUARY
S	M	T	W	T	F	S
		1	2	3	4	5
6	7	8	9	10	11	12
13	14	15	16	17	18	19
20	21	22	23	24	25	26
27	28	29	30	31		

FEBRUARY
S	M	T	W	T	F	S
					1	2
3	4	5	6	7	8	9
10	11	12	13	14	15	16
17	18	19	20	21	22	23
24	25	26	27	28		

MARCH
S	M	T	W	T	F	S
					1	2
3	4	5	6	7	8	9
10	11	12	13	14	15	16
17	18	19	20	21	22	23
24	25	26	27	28	29	30
31						

APRIL
S	M	T	W	T	F	S
	1	2	3	4	5	6
7	8	9	10	11	12	13
14	15	16	17	18	19	20
21	22	23	24	25	26	27
28	29	30				

MAY
S	M	T	W	T	F	S
			1	2	3	4
5	6	7	8	9	10	11
12	13	14	15	16	17	18
19	20	21	22	23	24	25
26	27	28	29	30	31	

JUNE
S	M	T	W	T	F	S
						1
2	3	4	5	6	7	8
9	10	11	12	13	14	15
16	17	18	19	20	21	22
23	24	25	26	27	28	29
30						

JULY
S	M	T	W	T	F	S
	1	2	3	4	5	6
7	8	9	10	11	12	13
14	15	16	17	18	19	20
21	22	23	24	25	26	27
28	29	30	31			

AUGUST
S	M	T	W	T	F	S
				1	2	3
4	5	6	7	8	9	10
11	12	13	14	15	16	17
18	19	20	21	22	23	24
25	26	27	28	29	30	31

SEPTEMBER
S	M	T	W	T	F	S
1	2	3	4	5	6	7
8	9	10	11	12	13	14
15	16	17	18	19	20	21
22	23	24	25	26	27	28
29	30					

OCTOBER
S	M	T	W	T	F	S
		1	2	3	4	5
6	7	8	9	10	11	12
13	14	15	16	17	18	19
20	21	22	23	24	25	26
27	28	29	30	31		

NOVEMBER
S	M	T	W	T	F	S
					1	2
3	4	5	6	7	8	9
10	11	12	13	14	15	16
17	18	19	20	21	22	23
24	25	26	27	28	29	30

DECEMBER
S	M	T	W	T	F	S
1	2	3	4	5	6	7
8	9	10	11	12	13	14
15	16	17	18	19	20	21
22	23	24	25	26	27	28
29	30	31				

2003

JANUARY

S	M	T	W	T	F	S
			1	2	3	4
5	6	7	8	9	10	11
12	13	14	15	16	17	18
19	20	21	22	23	24	25
26	27	28	29	30	31	

FEBRUARY

S	M	T	W	T	F	S
						1
2	3	4	5	6	7	8
9	10	11	12	13	14	15
16	17	18	19	20	21	22
23	24	25	26	27	28	

MARCH

S	M	T	W	T	F	S
						1
2	3	4	5	6	7	8
9	10	11	12	13	14	15
16	17	18	19	20	21	22
23	24	25	26	27	28	29
30	31					

APRIL

S	M	T	W	T	F	S
		1	2	3	4	5
6	7	8	9	10	11	12
13	14	15	16	17	18	19
20	21	22	23	24	25	26
27	28	29	30			

MAY

S	M	T	W	T	F	S
				1	2	3
4	5	6	7	8	9	10
11	12	13	14	15	16	17
18	19	20	21	22	23	24
25	26	27	28	29	30	31

JUNE

S	M	T	W	T	F	S
1	2	3	4	5	6	7
8	9	10	11	12	13	14
15	16	17	18	19	20	21
22	23	24	25	26	27	28
29	30					

JULY

S	M	T	W	T	F	S
		1	2	3	4	5
6	7	8	9	10	11	12
13	14	15	16	17	18	19
20	21	22	23	24	25	26
27	28	29	30	31		

AUGUST

S	M	T	W	T	F	S
					1	2
3	4	5	6	7	8	9
10	11	12	13	14	15	16
17	18	19	20	21	22	23
24	25	26	27	28	29	30
31						

SEPTEMBER

S	M	T	W	T	F	S
	1	2	3	4	5	6
7	8	9	10	11	12	13
14	15	16	17	18	19	20
21	22	23	24	25	26	27
28	29	30				

OCTOBER

S	M	T	W	T	F	S
			1	2	3	4
5	6	7	8	9	10	11
12	13	14	15	16	17	18
19	20	21	22	23	24	25
26	27	28	29	30	31	

NOVEMBER

S	M	T	W	T	F	S
						1
2	3	4	5	6	7	8
9	10	11	12	13	14	15
16	17	18	19	20	21	22
23	24	25	26	27	28	29
30						

DECEMBER

S	M	T	W	T	F	S
	1	2	3	4	5	6
7	8	9	10	11	12	13
14	15	16	17	18	19	20
21	22	23	24	25	26	27
28	29	30	31			

POSTERS BY ANSEL ADAMS

* The Tetons and the
Snake River

Clearing Winter Storm

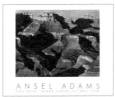
Cape Royal,
Grand Canyon

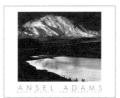
Mount McKinley and
Wonder Lake

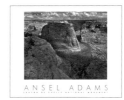
Canyon de Chelly

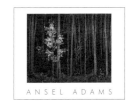
Aspens

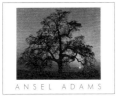
Oak Tree, Sunset City

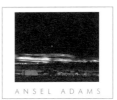
Moonrise, Hernandez,
New Mexico

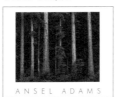
Redwoods

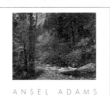
Tenaya Creek,
Dogwood, Rain

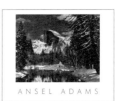
Half Dome,
Merced River, Winter

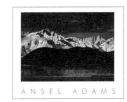
Winter Sunrise

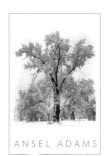
* Oak Tree,
Snowstorm

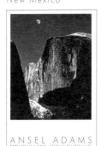
Moon and
Half Dome

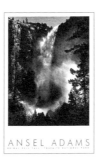
Bridal Veil Fall

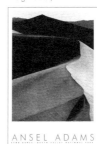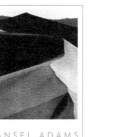
Sand Dunes,
Sunrise

Aspens

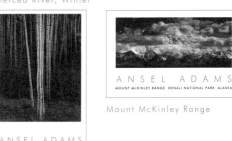
Mount McKinley Range

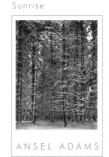
Pine Forest in Snow

Yosemite
National
Park

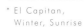
* Nevada Fall,
Rainbow

* El Capitan,
Winter, Sunrise

Monolith, the
Face of Half Dome

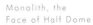
Our National Parks

* Also available in small format
For complete listing of available posters, see order form.

ORDER FORM

SHIP TO:

Name _____

Address _____

City _____

State _____ Zip _____

Daytime telephone _____

Please provide street address rather than post office box number as all shipments will be via United Parcel Service.

QUANTITY		PRICE	AMOUNT
	Books by Ansel Adams		
	The American Wilderness		
_____	Cloth (0-8212-1799-2)	$150.00	$ _____
	Ansel Adams at 100		
_____	Cloth, Slipcase (0-8212-2515-4)	$150.00	$ _____
	Ansel Adams: An Autobiography		
_____	Cloth (0-8212-1596-5)	$65.00	$ _____
_____	Trade Paper (0-8212-2241-4)	$14.45	$ _____
	Ansel Adams: Letters (1916–1989)		
_____	Paper (0-8212-2682-7)	$17.45	$ _____
	Ansel Adams: Classic Images		
_____	Cloth (0-8212-1629-5)	$40.00	$ _____
	Ansel Adams: Our National Parks		
_____	Paper (0-8212-1910-3)	$21.45	$ _____
	Ansel Adams: Yosemite		
_____	Paper (0-8212-2196-5)	$21.45	$ _____
	Ansel Adams in Color		
_____	Cloth (0-8212-1980-4)	$65.00	$ _____
	California		
_____	Cloth (0-8212-2369-0)	$50.00	$ _____
	Examples: The Making of 40 Photographs		
_____	Paper (0-8212-1750-X)	$37.00	$ _____
	The Grand Canyon and the Southwest		
_____	Paper (0-8212-2650-9)	$21.45	$ _____
	Photographs of the Southwest		
_____	Cloth (0-8212-0699-0)	$50.00	$ _____
	The Portfolios of Ansel Adams		
_____	Cloth (0-8212-0723-7)	$45.00	$ _____
	Yosemite and the High Sierra		
_____	Cloth (0-8212-2134-5)	$55.00	$ _____
	The Ansel Adams Guide: Basic Techniques of Photography, Book One: Revised Edition, by John P. Schaefer		
_____	Cloth (0-8212-2613-4)	$60.00	$ _____
_____	Paper (0-8212-2575-8)	$38.45	$ _____
	The Ansel Adams Guide: Basic Techniques of Photography, Book Two, by John P. Schaefer		
_____	Cloth (0-8212-2095-0)	$60.00	$ _____
_____	Paper (0-8212-1956-1)	$38.45	$ _____
	The Camera/Book 1		
_____	Paper (0-8212-2184-1)	$22.00	$ _____
	The Negative/Book 2		
_____	Paper (0-8212-2186-8)	$22.00	$ _____
	The Print/Book 3		
_____	Paper (0-8212-2187-6)	$22.00	$ _____
	Posters by Ansel Adams		
	Large format		
	Aspens, Northern New Mexico (horizontal) (0-8212-2406-9)		
_____		$30.00	$ _____
	Aspens, Northern New Mexico (vertical) (0-8212-2428-X)		
_____		$30.00	$ _____
	Bridal Veil Fall (0-8212-2407-7)		
_____		$30.00	$ _____
	Canyon de Chelly National Monument (0-8212-2391-7)		
_____		$30.00	$ _____
	Cape Royal, Grand Canyon (0-8212-2409-3)		
_____		$30.00	$ _____
	Clearing Winter Storm (0-8212-2410-7)		
_____		$30.00	$ _____
	El Capitan, Winter, Sunrise (0-8212-2411-5)		
_____		$30.00	$ _____
	Half Dome, Merced River (0-8212-2660-6)		
_____		$30.00	$ _____
	Monolith, the Face of Half Dome (0-8212-2412-3)		
_____		$30.00	$ _____
	Moon and Half Dome (0-8212-2413-1)		
_____		$30.00	$ _____
	Moonrise, Hernandez, New Mexico (0-8212-2414-X)		
_____		$30.00	$ _____
	Mount McKinley and Wonder Lake (0-8212-2415-8)		
_____		$30.00	$ _____
	Mount McKinley Range, Clouds (0-8212-2416-6)		
_____		$30.00	$ _____
	Nevada Fall, Rainbow (0-8212-2390-9)		
_____		$30.00	$ _____
	Oak Tree, Snowstorm (0-8212-2419-0)		
_____		$30.00	$ _____
	Oak Tree, Sunset City (0-8212-2420-4)		
_____		$30.00	$ _____

continued on overleaf

Pine Forest in Snow
(0-8212-2421-2) $30.00 $ _____

Redwoods
(0-8212-2422-0) $30.00 $ _____

Sand Dunes, Sunrise
(0-8212-2423-9) $30.00 $ _____

Tenaya Creek, Dogwood, Rain
(0-8212-2425-5) $30.00 $ _____

The Tetons and the Snake River
(0-8212-2426-3) $30.00 $ _____

Winter Sunrise
(0-8212-2427-1) $30.00 $ _____

Yosemite Valley, Winter
(0-8212-2183-3) $30.00 $ _____

Large format, color
Lone Pine Peak (0-8212-2055-1) $30.00 $ _____

Small format
Rose and Driftwood
(0-8212-2662-2) $20.00 $ _____

Thundercloud, Unicorn Peak
(0-8212-2661-4) $20.00 $ _____

Georgia O'Keeffe and Orville Cox
(0-8212-2663-0) $20.00 $ _____

El Capitan, Winter, Sunrise
(0-8212-2721-2) $10.00 $ _____

Nevada Fall, Rainbow
(0-8212-2720-3) $10.00 $ _____

Oak Tree, Snowstorm
(0-8212-2718-1) $10.00 $ _____

The Tetons and the Snake River
(0-8212-2719-X) $10.00 $ _____

Our National Parks
(0-8212-2725-4) $20.00 $ _____

Yosemite National Park
(0-8212-2724-6) $20.00 $ _____

Calendars and Address Book
Ansel Adams 2002 Wall Calendar
(0-8212-2583-9) $17.95 $ _____

Ansel Adams 2002 Engagement
Calendar (0-8212-2584-7) $17.95 $ _____

Ansel Adams Address Book
(0-8212-2510-3) $25.00 $ _____

Ansel Adams Postcard Folio Books
30 Photographs
(0-8212-2105-1) $10.95 $ _____

Winter Photographs
(0-8212-2135-3) $10.95 $ _____

The National Parks
(0-8212-2181-7) $10.95 $ _____

Color Photographs
(0-8212-2240-6) $10.95 $ _____

Yosemite National Park
(0-8212-2283-X) $10.95 $ _____

The Southwest
(0-8212-2344-5) $10.95 $ _____

California Photographs
(0-8212-2478-6) $10.95 $ _____

Ansel Adams at 100
(0-8212-2585-5) $10.95 $ _____

SUBTOTAL $ _____

California, Massachusetts, and New York
residents must include applicable sales tax. $ _____

TOTAL $ _____

☐ I enclose check/money order payable to Little, Brown and Company
for the total due above. Publisher pays postage and handling.
OR
☐ Charge my ☐ American Express ☐ VISA ☐ MasterCard

$1.50 for one item, and $.50 for each additional item ordered, will
be charged for handling. Postage will be determined by weight.

Account number _____

Expiration date _____ Signature _____

Posters are non-returnable. *Prices shown on this order form are current
prices and are subject to change without notice.*

SEND ORDERS TO: **OR CALL TOLL-FREE:**
Little, Brown 1-800-759-0190
Customer Service
Three Center Plaza
Boston, MA 02108 Also available at bookstores